WHERE THE WORLD DOES NOT FOLLOW

BUDDHIST CHINA IN PICTURE AND POEM

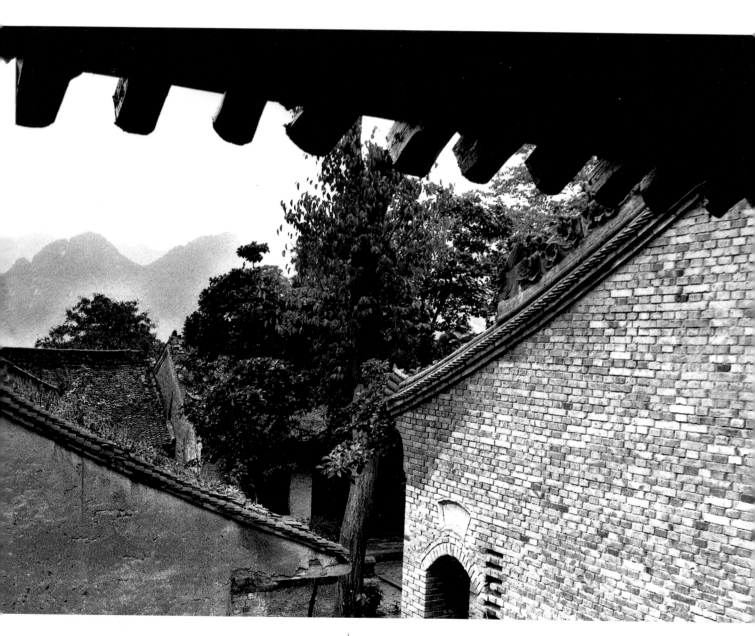

Wisdom Publications • Boston

Wisdom Publications
199 Elm Street
Somerville MA 02144 USA
wisdompubs.org

Library of Congress Cataloging-in-Publication Data

Johnson, Steven R.
 Where the world does not follow : Buddhist China in picture
 and poem / edited and translated by Mike O'Connor ;
 photographs by Steven R. Johnson ; foreword by William Neill.
 p. cm.
 Includes bibliographical references and index.
 ISBN 0-86171-309-5 (alk. paper)
 1. Buddhism—China. 2. Taoism—China. 3. Chinese poetry—
 Tang dynasty, 618–907—Translations into English. I. O'Connor
 Mike. II. Title. III. Buddhist China in picture and poem.
 BQ647.J64 2002
 294.3'0951—dc21 2002005233

First Wisdom Edition
07 06 05 04 03 02
 6 5 4 3 2 I

ISBN 0-86171-309-5

Cover and interior designed by Gopa & Ted2.
Chinese typesetting by Tri-Star Printing and Graphics.
Cover: Dragon Spine and mist on Hua-shan, Shensi Province,
 by Steven R. Johnson.
Title page: Master Tao-hsuan's (c. 630 A.D.) Ching-yeh Temple in the
 Chung-nan Mountains, Shensi Province, by Steven R. Johnson.

Wisdom Publications' books are printed on acid-free paper and meet
the guidelines for permanence and durability of the Production Guide-
lines for Book Longevity of the Council on Library Resources.

Printed in Singapore.

TABLE OF CONTENTS

FOREWORD

In a world too often blighted by ugliness and chaos, the contemplation of beauty is more important than ever. Dew glittering on flowers, warmth in the eyes of a stranger, or the soothing shapes of clouds on the horizon—noticing these connects us to the source of our daily existence. Not only is such observation an important reassurance of goodness in the world, it is a vital act of prayer, of meditation, that drives the positive evolution of the human mind and condition. The pursuit of beauty is not escapist, or elitist. And the power of such positive focus of our minds is undeniable.

Where the World Does Not Follow reveals to us an ancient world where seekers of beauty endeavored to distill life's elemental truths with their poetry. Mike O'Connor's selection of poems, written by sages and others in quest of wisdom, are unified by a deep mood of simplicity and peacefulness.

Simultaneously, we are shown images of the modern Chinese world—photographs of real landscapes and real people—that connect us to the poets' words. The blending of word and image creates a vivid sense of the thread that connects the past, present, and future. Steven R. Johnson's black-and-white photographs show little context of time; the images are modern yet appear timeless, reinforcing the seamless effect. Some images are formal and unswerving, looking directly at the object of his attention. Others, seemingly casual in composition, gaze outward as if to illustrate the poet's source of inspiration. And some seem to have been taken at the exact line of vision when a poignant thought came to the poet's mind as he contemplated misty mountains or graceful pine boughs. Both styles complement the calm temperament of the poems.

Where the World Does Not Follow celebrates and perpetuates the hermit-sage tradition in the individual works of word and image, but also in the collaboration of O'Connor and Johnson themselves. They themselves seek a deeper level of knowledge and understanding as seen in their own work, and most strongly, as harmonized within their collaboration. By extension, we are inspired to give ourselves the time and space to contemplate beauty. We need the solace of sanctuary, whether it be in meditation, in prayer, or walking in the solitude of wilderness. We are also offered such sanctuary within the pages of this book.

William Neill

TRANSLATOR'S PREFACE

IN THE SPRING OF 1989—coincident with the mass protest movement in Tienanmen Square—Steve Johnson and Bill Porter set out on a journey to the mountains of China in hopes of locating remnants of the hermit-sage tradition, a tradition dating back well over two thousand years. As recounted in Porter's book, *Road to Heaven,* their search was not in vain. The hermits they encountered—Buddhist, Taoist, a mixture of the two, and other less-defined spiritual adepts—were still there in the mountains in temples, huts, and caves, practicing in various modes the Way, also called the Tao, that their ancestors had cultivated.

Johnson's photographic record of that (and one other) journey are featured in this volume. The pictures are paired with my translations of a number of T'ang Dynasty (618–906) poets, many of whom in their own day also went looking for recluses—and wisdom—in those same mountains. Some of the poets translated here were, in fact, hermits themselves (like Han-shan and T'ai-shang Yin-che); a number were Buddhist monks (such as Kuan-hsiu and Ch'i-chi); or Buddhist laymen (Po Chu-i and Wang Wei). Yet others were inclined more to Taoism (like Li Po); or were scholar-officials (Yao Ho, for instance), drawing poetic inspiration from the quietism and natural settings of mountain retreat, though remaining engaged in the political world.

In the course of this project, Steve and I have often reviewed one another's work and matched up poems and pictures. From the beginning we hoped in our collaboration to achieve something different than having poems adorn photographs or photographs illustrate poems. We wanted both works—poems and pictures—to be complete in themselves, but when joined together, each capable of deepening the emotion of the other, creating, in effect, a third work, a larger whole that ideally evokes a felt sense of things beyond either words or visual representation.

This work, linking ancient poetry and modern photography across a span of a thousand years, is an aesthetic response to the esteemed hermit-sage tradition, or what came to be known by T'ang times as the "White Clouds." This mountain tradition, which included early shamans, Taoists, and Confucian "high-minded gentlemen" who eschewed political office, was also receptive to the first Buddhist monks from India, and in time gave birth to Ch'an, or Zen, Buddhism,

the most flourishing religious sect of the T'ang. Despite the enormous cultural and political upheavals in China through the ages, the White Clouds largely remain today, as before, a realm of reclusion and self-realization where the world does not follow.

TRANSLATOR'S NOTE

Most of the poems in this book were written in modern-style *lu-shih* (regulated verse) form consisting of eight lines of five or seven characters each. This form requires well-chosen end rhymes and complex tonal arrangements. It also calls for a scheme of parallel lines for the two inner couplets. (See "Farewell to Monk Ho-lan," by Chia Tao.)

The regulated *chieh-chu* (cut-lines) form is also well represented here. This quatrain, while following the same metrical rules as that of the eight-line *lu-shih*, is a self-contained form. (See "Looking for Immortals," by Chang Chi.)

Several poems in this collection were written in *ku-shih* (old-style) form. These are poems after an ancient style. While they have no set length, they still follow the pattern of either five or eight characters to the line. (See "Color-of-Nature Gorge," by Wang Wei.)

With a few exceptions, the style of romanization throughout this book is modified Wade-Giles.

ACKNOWLEDGMENTS

Several of these poems first appeared in my books *The Rainshadow* and *The Basin: Life in a Chinese Province*, Empty Bowl Books, Port Townsend; and in chapbooks from Tangram, Berkeley. Others have appeared in these magazines: *Dalmo'ma, Gate, Longhouse, Mudlark, The Literary Review, Two Rivers,* and *Vigilance.*

I wish to thank Osman Tseng, Jim Ball, Bruce Shafer, and Terrell Guillory for their friendship and wise counsel; and to remember Bruce (Bub) Schade, "who loved the beauty of valleys and hills." Thanks also to the sangha of Sitting Frog Zendo. And a tip of my hat to old comrades Steve Johnson and Bill Porter. On behalf of both Steve and myself, a deep bow to the staff at Wisdom Publications, and to Gopa & Ted2. At Wisdom, Tim McNeill, Josh Bartok, and Samantha Kent were invaluable partners in the shared creation of this work.

PHOTOGRAPHER'S PREFACE

PHOTOGRAPHY HAS OFFERED me many challenges and taken me on many journeys. As an artist I strive to see the beauty in things and find the unseen in the moment. As a photographer I try to capture an essence and a glimpse of this beauty on film.

The photographs in this volume were taken with two 35-mm Nikons during two trips to China over the course of three years. The trip, begun in 1989, was a passionate quest by translator-writer Bill Porter to find Buddhist and Taoist hermits in the misty mountains of China. Bill invited me along to document the trip visually. We began in northern China and zigzagged south through sparsely populated areas where Buddhism once flourished. But it was said that there had been no more hermits there since the era of Mao Tse-tung.

After looking for but not finding hermits for several weeks, we finally came upon one at Ching-yeh Temple in the Chung-nan Mountains near Xian, Shensi Province. This was the monk K'uan-ming, who later became our guide in meeting other elusive hermits. For the next three months, we went up and down mountain paths seeking out hermits in their huts. The photographs in this volume include images of temples and mountain hermitages that we visited, as well as scenes and people we encountered along the way. In a second trip, again with Bill, and also with poet Finn Wilcox, I captured images of many other famous and historical sites in southeast China.

None of this project's photography could have been realized without Bill Porter, who took me to China and who has provided me with a darkroom in his basement. I would also like to thank others who have supported me in my China photographic work and with this book: Ku Lien-chang, David and Kathy Johnson, Chris Johnson, Leonard and Barbara Davis, Sharon Lia Robinson, Christina McLennan, Barbara Morgan, Rusty and David North, Coleen Bennett McGrady, Lauri Chambers, Terrell Guillory, Leon Crowel, Chuck Easton, Autumn Scott, Joe Karniewicz, Finn Wilcox, Mike O'Connor, and the Centrum Foundation of Port Townsend.

PUBLISHER'S ACKNOWLEDGMENT

The Publisher gratefully acknowledges the
generous help of the Hershey Family Foundation
in sponsoring the production of this book.

PHOTOGRAPHER'S DEDICATION

To my mother,
Peggy S. Johnson

Bill Porter

and to my father,
Harold I. Johnson

TRANSLATOR'S DEDICATION

To Ling-hui

THE POEMS

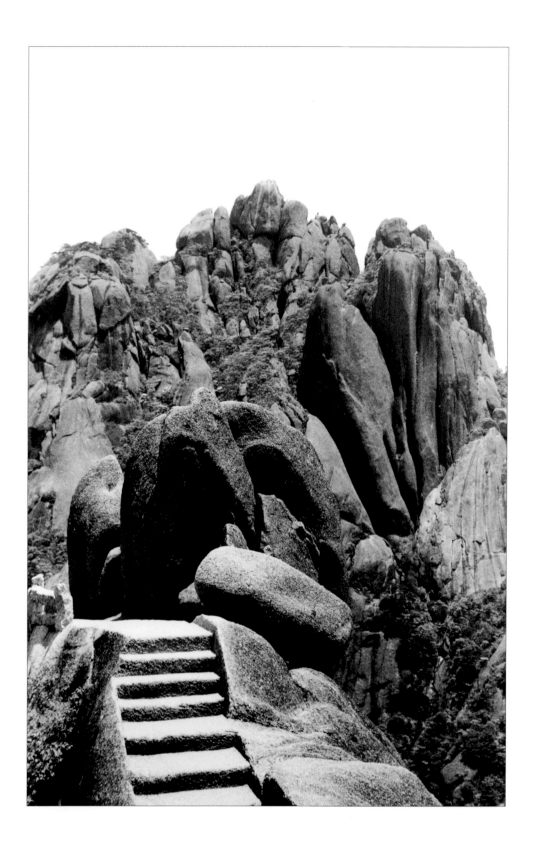

Looking for Immortals

CHANG CHI

At the stream's source,
the path leads on
to gray cliffs.

Everywhere,
among blossoming apricot trees,
dwell Immortals.

A hermit says,
"More can be found
on West Peak,

and two or three
have their home
in the clouds."

尋仙　　張籍

溪頭一徑入青崖處處仙居隔杏花

更見峰西幽客說雲中猶有兩三家

13

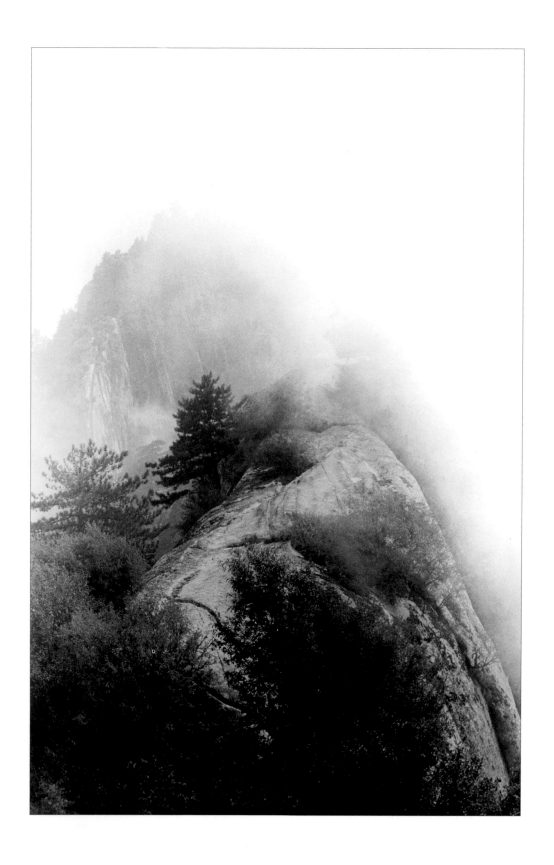

A Chung-nan Mountain Monk

KUAN-HSIU

The voice of success and profit
may stir the vault of heaven,
but not this place.

In the rounds of the day,
you wear threadbare clothing
and eat simple fare.

When the mountain snow deepens,
your thoughts
are far from those of men.

Occasionally,
Immortals pass your door
and knock.

終南僧　　　　　貫休

聲利掀天竟不聞草衣木食度朝昏

遙思山雪深一丈時有仙人來打門

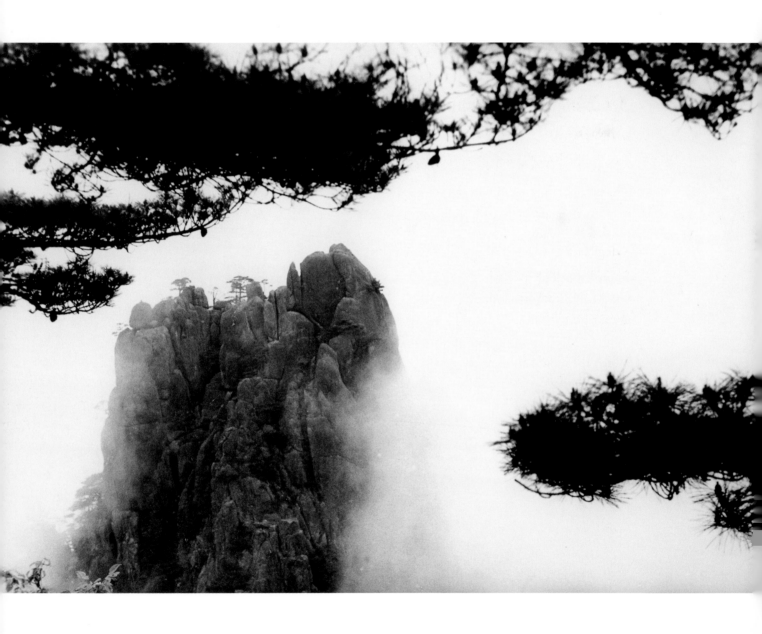

On Going to See a Taoist Master on Tai-t'ien Mountain but Not Finding Him Home

LI PO

A dog barks
amid the sound of water;
a heavy dew stains
peach blossoms.

In these deep woods,
I see several deer;
at noon along the stream,
I hear no temple bell.

Wild bamboo
divides gray clouds;
waterfalls hang
from blue peaks.

No way to tell
where you've gone;
disheartened, I lean
against a second, now a third pine.

訪戴天山道士不遇　李白
犬吠水聲中桃花帶雨濃
樹深時見鹿溪午不聞鐘
野竹分青靄飛泉挂碧峰
無人知所去愁倚兩三松

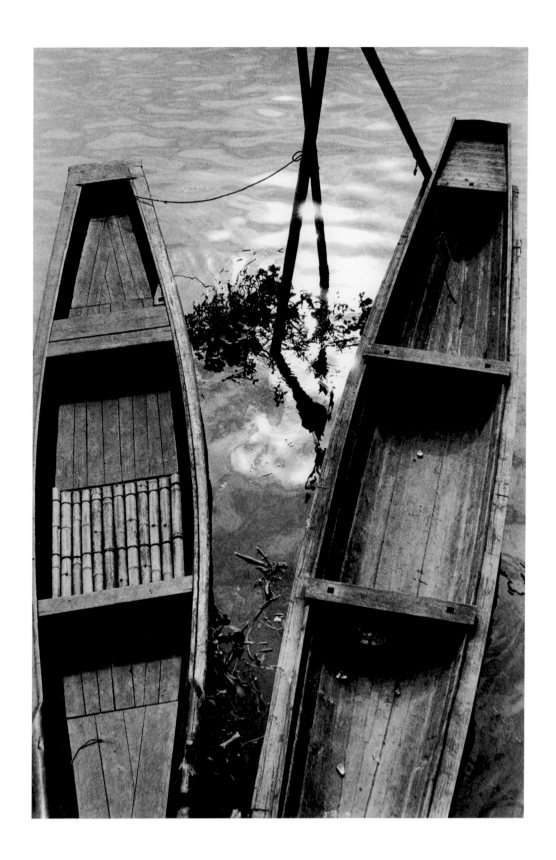

Color-of-Nature Gorge

WANG WEI

To reach Chrysanthemum River
I always follow Ch'ing Gorge Stream
through the mountains, through
ten thousand twists and turns—
a fine trip and not a hundred *li*.

The noise among boulders is tremendous,
the view into pines, serene;
swirling water chestnut,
distilled reflections of reeds.

My original mind is unstriving,
a pure, tranquil stream, like that.
I could stay on some big rock slab,
fishing, forever.

青谿

王維

言入黃花川　每逐清谿水　隨山將萬轉　趣途無百里

聲喧亂石中　色靜深松裡　漾漾汎菱荇　澄澄映葭葦

我心素已閒　清川澹如此　請留盤石上　垂釣將已矣

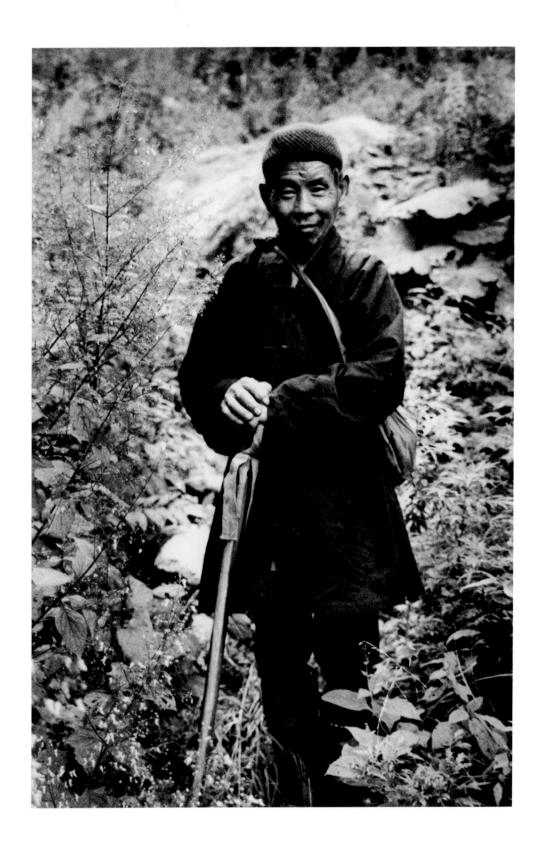

Farewell to Monk Ho-lan

CHIA TAO

When you, O wild monk,
come to say good-bye,
we sit for a while
by the sandy creek.

On far roads,
you hold out an empty bowl;
deep in mountains,
walk on fallen flowers.

Having no master, you
puzzle out Zen on your own;
observing strict prosody,
your poems merit praise.

This going-away
has no circumstantial cause;
a solitary cloud
has no fixed home.

送賀蘭上人　賈島

野僧來別我略坐傍泉沙遠道擎空缽深山踏落花

無師禪自解有格句堪誇此去非緣事孤雲不定家

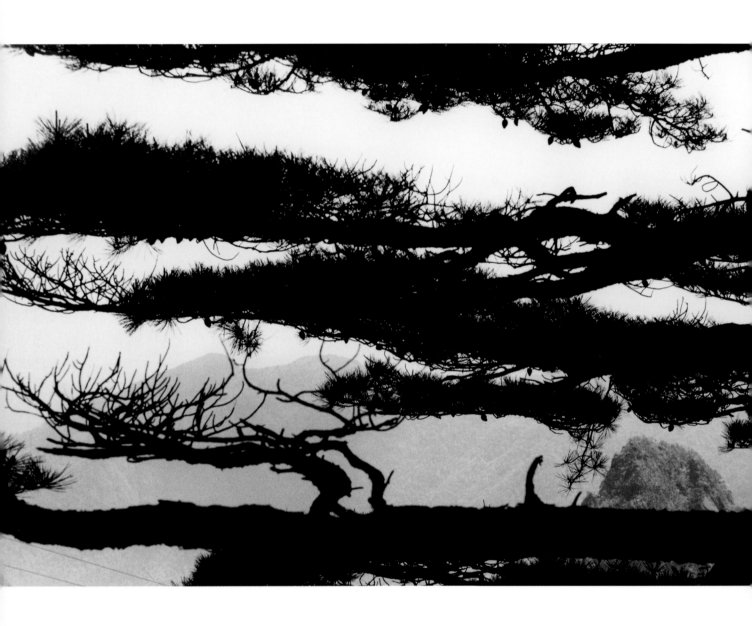

Answer

T'AI-SHANG YIN-CHE

Walking about
in this pine wood,
I find an accommodating rock
on which to nap.

In the mountains,
there aren't any calendars;
and though I know winter's cold has ended,
I haven't a clue to the year.

答人

太上隱者

偶來松樹下高枕石頭眠山中無曆日寒盡不知年

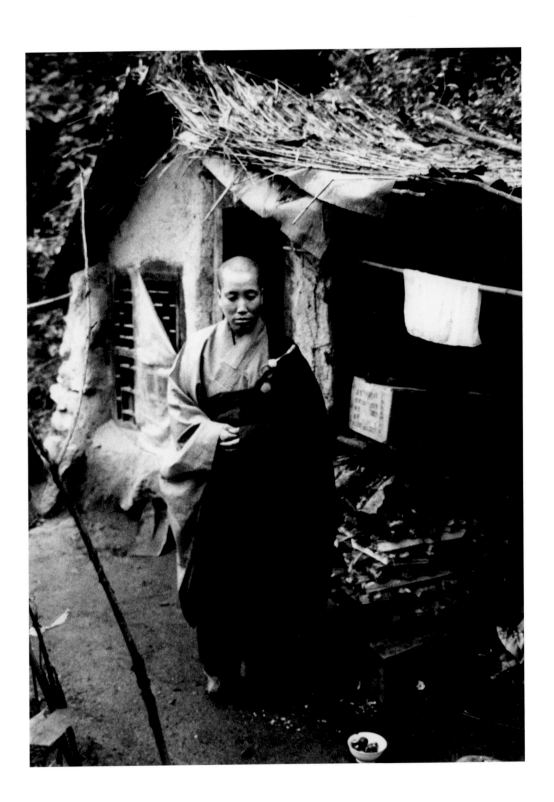

Getting Up in the Night and Viewing the West Garden As the Moon Rises

LIU TZUNG-YUAN

Waking from sleep,
I can hear the dew in the trees.
I open my door
overlooking the garden.

The winter moon
clears the eastern cliffs;
water murmurs
through roots of bamboo.

The mountain stream's
beyond my hearing,
but a mountain bird cries once,
and…then again.

Leaning in the doorway,
I follow night through to dawn.
What words can I summon
for such mystery and peace?

柳宗元

中夜起望西園值月上

覺聞繁露墜開戶臨西園

寒月上東嶺泠泠疏竹根

石泉遠逾響山鳥時一喧倚楹遂至旦寂寞將何言

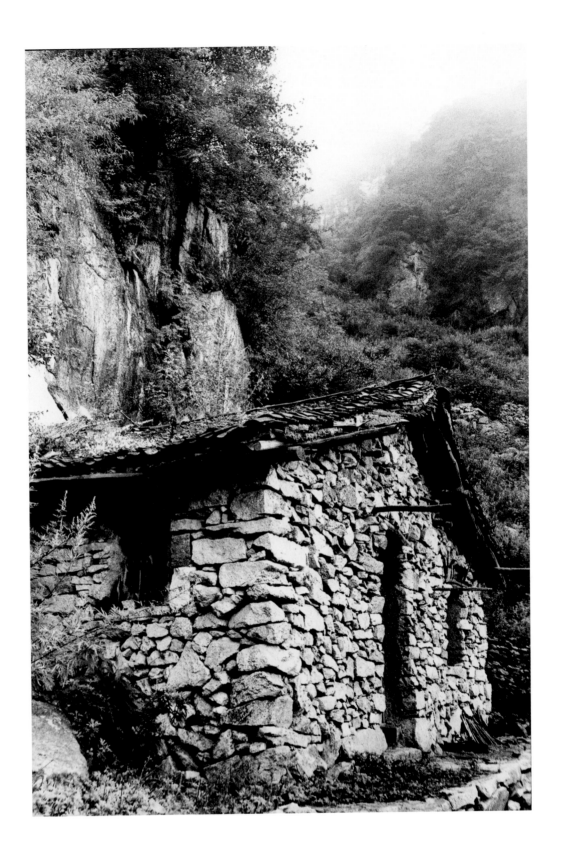

In the Mountains

SZU K'UNG-T'U

Common birds
love to chatter
where men live quiet lives.

Peaceful clouds
seem jealous
when the moon is bright.

In the world,
the ten thousand affairs
are not my affairs.

My only shame—
it's autumn,
and I have no poem.

山中

凡鳥愛喧人靜處
閒雲似妒月明時
世間萬事非吾事
只愧秋來未有詩

司空圖

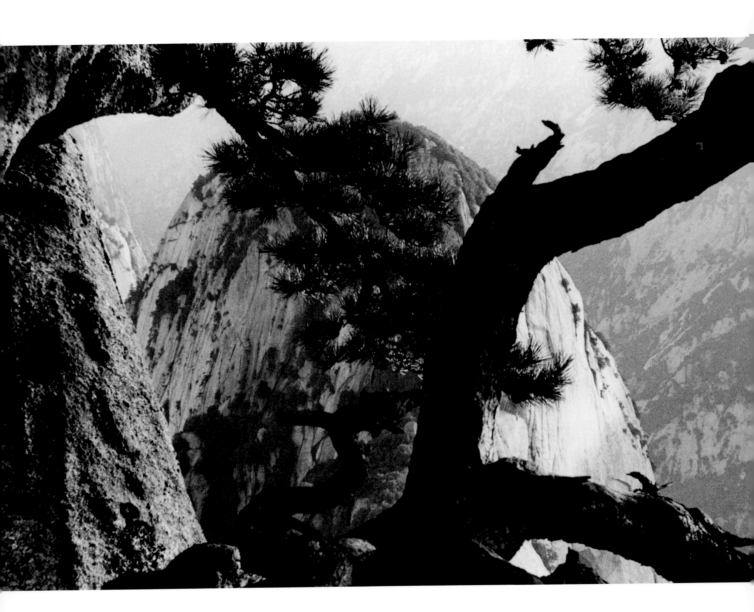

Upper Cell of Fa-hua Temple
——for Monk Ch'an-k'ung

CHIAO-JAN

The trail enters
pines, the sound of pines;
the farther one goes,
the rarer the sound.

Mountain light
colors
the river water.

Among peaks,
a monk sits
Zen,

facing an old branch
of a cassia tree,
once a seedling in the Liang.

法華寺上方題江上人禪空　皎然

路入松聲遠更奇山光水色共參差

中峰禪寂一僧在坐對梁朝老桂枝

29

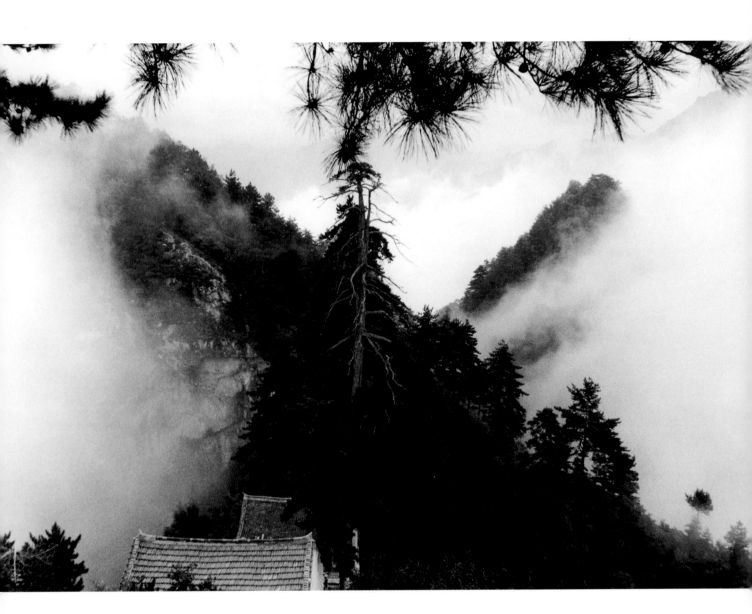

In Autumn, Dwelling at Fa-hua Temple, Gazing Up at High Peaks from the Courtyard
—for Monk Ju-hsien

CHIAO-JAN

I view the colored peaks
incised upon the autumn sky;
listen to the pine grove
in the calm night.

Someone not seen
for a long time
is practicing the Way
in snowy clouds.

峰　秋　居　法　華　寺　下　院　望　高　峰　贈　如　獻　上　人　　皎
色　天　見　松　聲　靜　夜　聞　影　孤　長　不　出　行　道　在　寒　雲　然

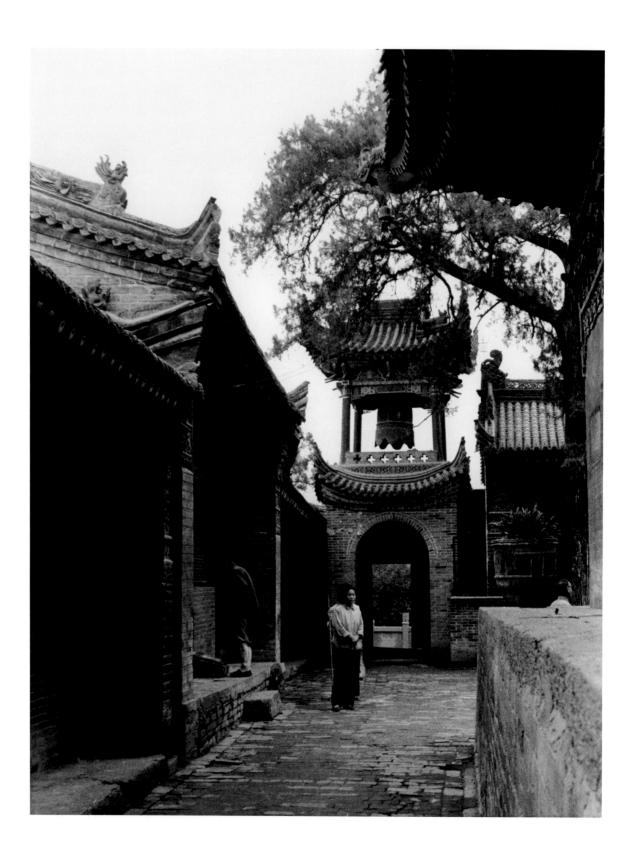

Passing by Monk Rung's Monastery

MENG HAO-JAN

In the mountains,
a monk's robe hangs
in the meditation hall.

Outside the window,
no one's to be seen—
only birds skimming over the creek.

As I descend,
dusk meets me halfway
down the mountain road.

Still hearing the creek fall,
I hesitate, reluctant
to leave these blue heights.

過融上人蘭若　孟浩然

山頭禪室挂僧衣窗外無人溪鳥飛

黃昏半在下山路卻聽泉聲戀翠微

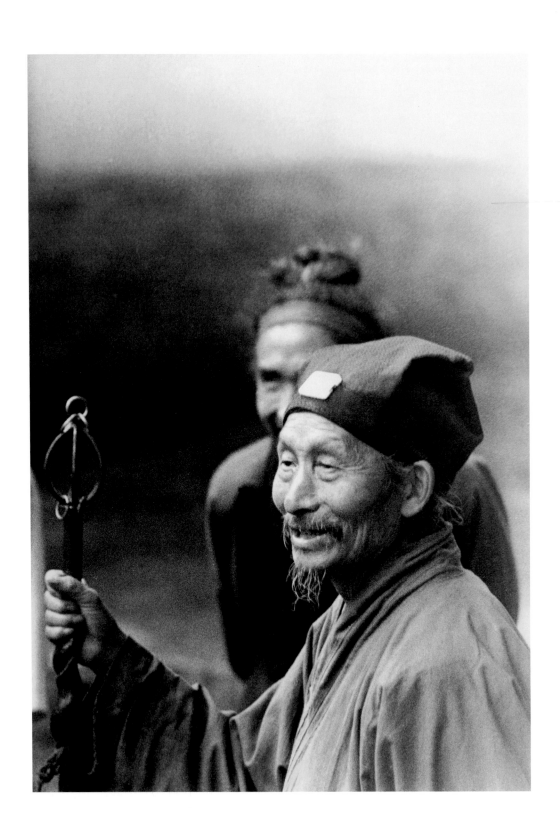

Written at Yuan Tan-ch'iu's Mountain Retreat

LI PO

An old friend who lives on Tung Mountain
loves the beauty of valleys and hills.

In green spring, he rests in empty woods
and sleeps though the sun is high.

Pine wind rustles his collar and sleeve;
the deep, rocked pool cleanses heart and ear.

I envy this man who suffers no delusions,
his high pillow wreathed by green clouds.

題元丹丘山居　　李白

故人棲東山自愛丘壑美青春臥空林白日猶不起

松風清襟袖石潭洗心耳羨君無紛喧高枕碧霞裡

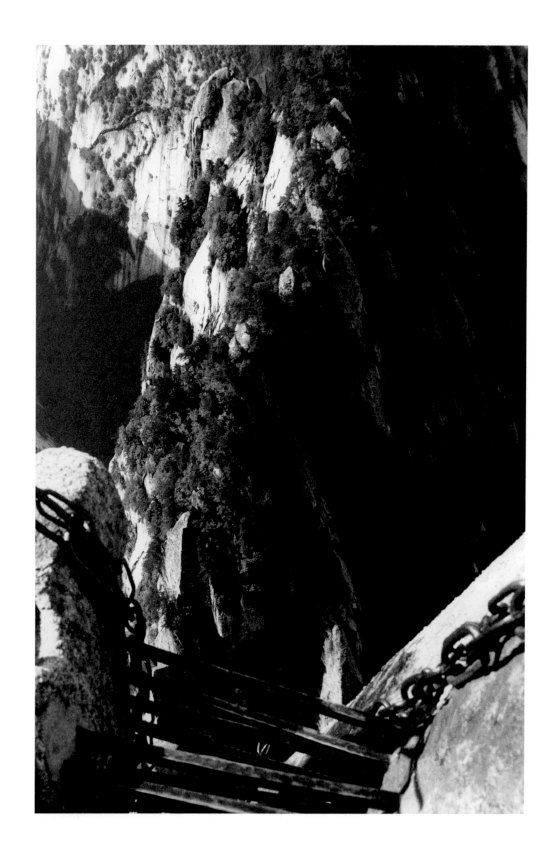

Mountain Travel

TU MU

Far up this cold mountain,
a steep rocky trail
leads to places men dwell
in white clouds.

I stop my horse-drawn cart,
sit and enjoy sunset through the maples,
whose frosted leaves are redder
than early spring flowers.

山行

杜牧

遠上寒山石徑斜　白雲生處有人家
停車坐愛楓林晚　霜葉紅於二月花

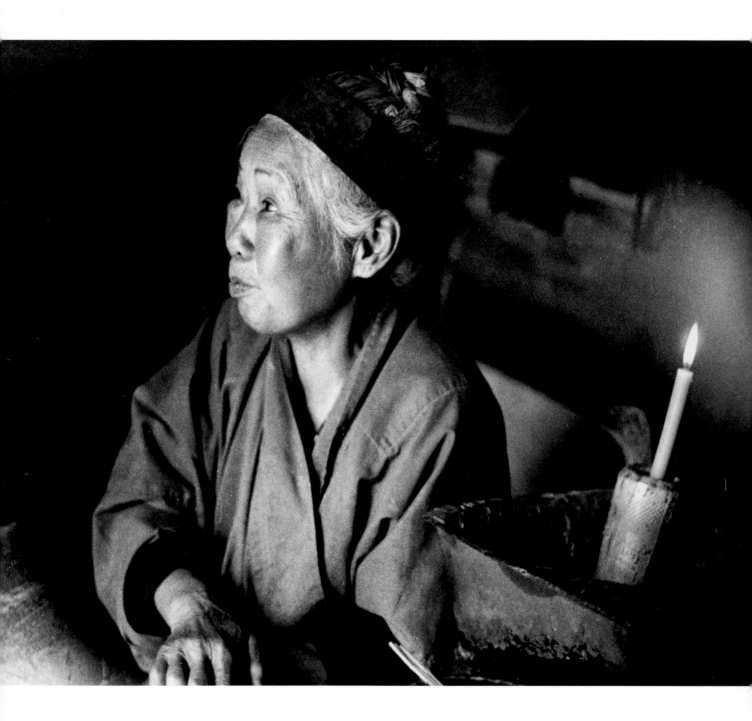

Fasting Taoist Woman, Residing in Mountains

CHANG CHI

Stillness, stillness
in the flowering branches—
at the thatched hut,
swept strings of a zither.

Because you're now in mountains,
the way you see has changed;
when meeting visitors,
you do not speak your heart.

The moon rises
over the quiet river road;
cranes cry from trees
deep in cloud.

If I could learn
the art of alchemy,
I, too, would settle
in an unknown wood.

月出溪路靜鶴鳴雲樹深丹砂如可學便欲住幽林

寂寂花枝裡草堂唯素琴因山曾改眼見客不言心

不食仙姑山房　　張籍

39

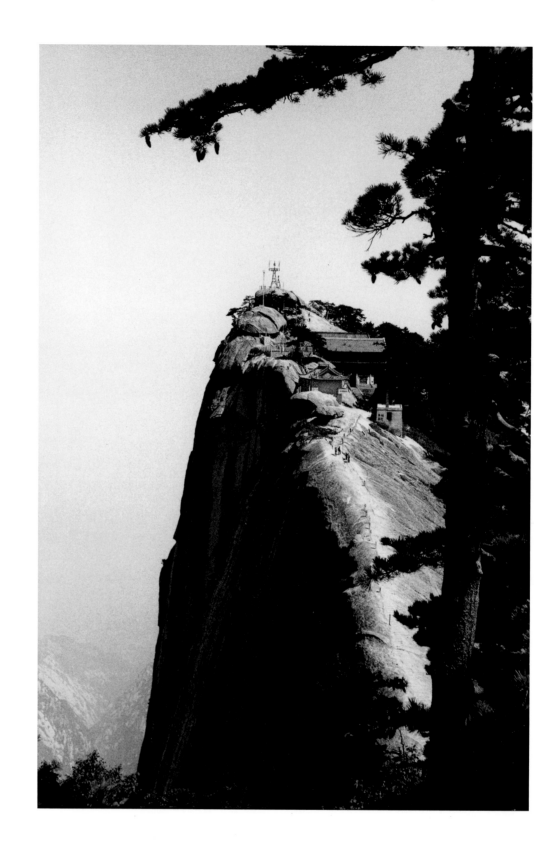

Written at a Quiet Retreat

KUAN-HSIU

At a private gate,
a light snow falls;
here the quietist's "scheme"
is perfectly achieved.

Meditation proceeds
through the day;
only lone peaks
compare in purity.

I'm at ease
in this insignificant dream;
fir and bamboo
stir in the cold.

There's only one old man
on West Peak,
and when we meet,
his eyes shine clear.

閒居作

貫休

閑門微雪下慵惰計全成默坐便終日孤峰祇此清

閒門微雪下慵惰計全成默坐便終日孤峰祇此清

身心閒少夢杉竹冷多聲唯有西峰叟相逢眼最明

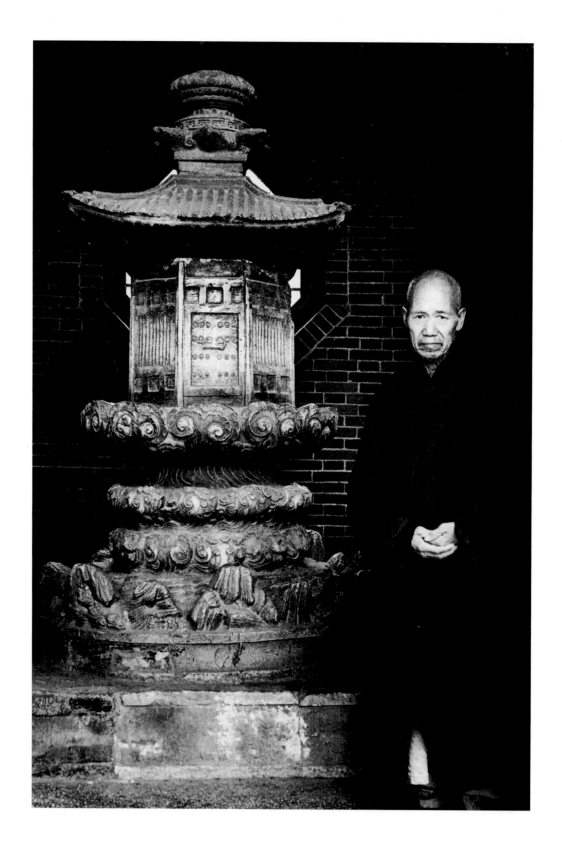

Ling-ling Temple

HSIEH LING-CHIH

He stays in a thatched hut
in Ling Mountain Valley;
studies diligently by oil lamp
the *Odes* and *History*.

In this still world without people,
his rustic door's half shut;
only white clouds go with him
through the night.

靈巖寺　　薛令之

草堂棲在靈山谷勤苦詩書向燈燭

柴門半掩寂無人惟有白雲相伴宿

43

Farewell to a Palace Lady Entering the Way

CHANG CHI

In the old Han Emperor's
Chao-yang Palace,
a woman most rare
sought to make Immortal.

Her name originally stood out
in palace records;
she was not yet familiar
with robes of colored clouds.

But she stopped
singing and dancing (both much praised)
and long followed
the flight of the crane.

Officials of the Court
stood by as she entered a mountain cave;
then drove the jade-wheeled car
home empty.

送宮人入道

舊寵昭陽裡尋仙此最稀名初出宮籍身未稱霞衣

已別歌舞貴長隨鸞鶴飛中官看入洞空駕玉輪歸

張籍

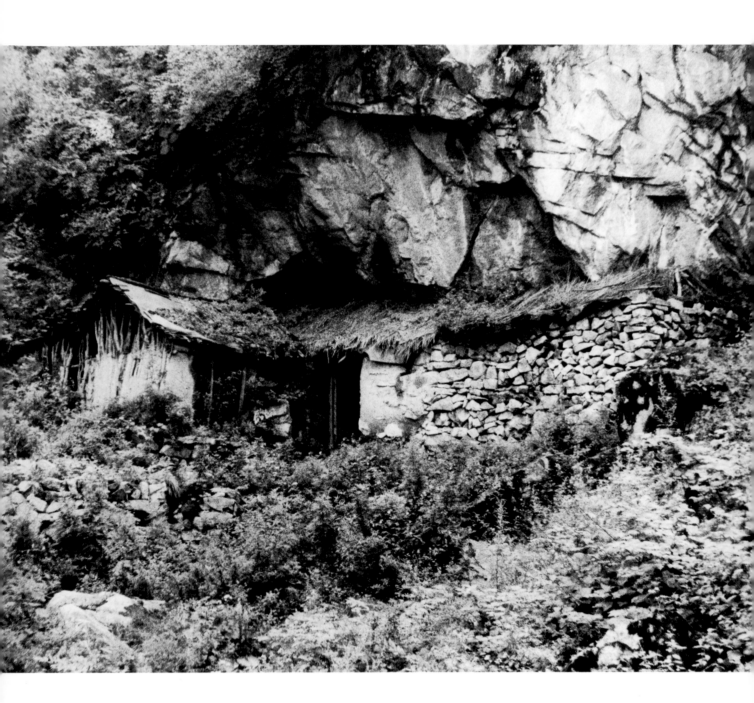

Seeing Off Monk I

CHIAO-JAN

The westering sun
flares in the willow silk;
the river meanders far off
from the hushed pavilion.

Who, after parting,
will comfort the weary traveler?
There is only spring wind rising
where the road forks.

誰　斜　送
堪　日　僧
別　搖　繹
後　揚
行　在　　皎
人　柳　　然
盡　絲
唯　孤
有　亭
春　寂
風　寂
起　水
路　逶
岐　迤

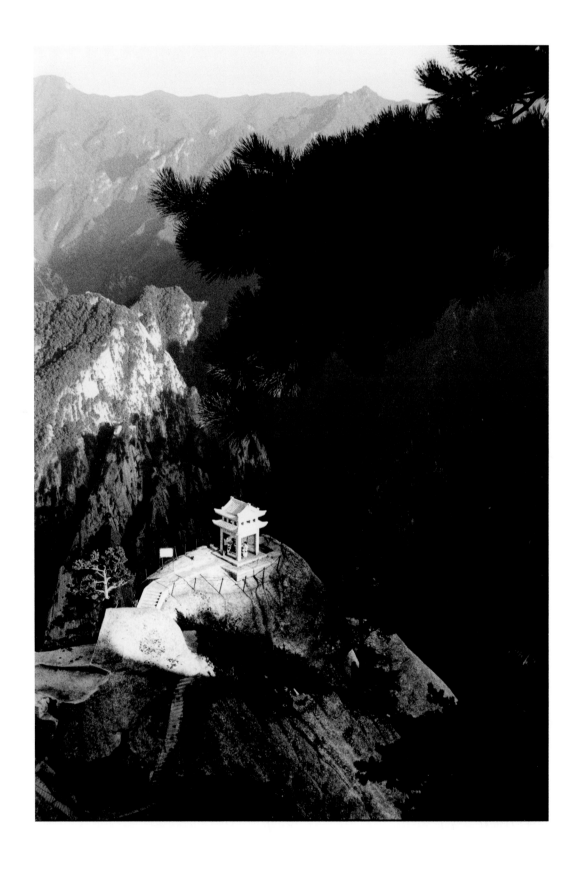

Looking for but Not Finding the Recluse of West Peak

CH'IU WEI

On the mountain top: one thatched hut,
thirty *li* from roads.

Knock on the door: no disciple to answer;
look in: only a table for tea.

The firewood cart is covered;
have you gone fishing in the autumn stream?

I look among the pools, but miss you;
I try but fail to pay you my respects.

Grass shines in the fresh rain;
pines murmur at evening windows.

Here at this moment a harmony, profound and unrivaled;
the self completely cleansed, the heart, the ear.

Although there is no guest or host as such,
I'm able to intuit your pure thought.

Purpose fulfilled, I head back down the mountain—
no need now to wait for you.

尋西山隱者不遇　　　邱為

絕頂一茅茨直上三十里扣關無僮僕窺室唯案几
若非巾柴車應是釣秋水差池不相見黽勉空仰止
草色新雨中松聲晚窗裡及茲契幽絕自足蕩心耳
雖無賓主意頗得清淨理興盡方下山何必待之子

49

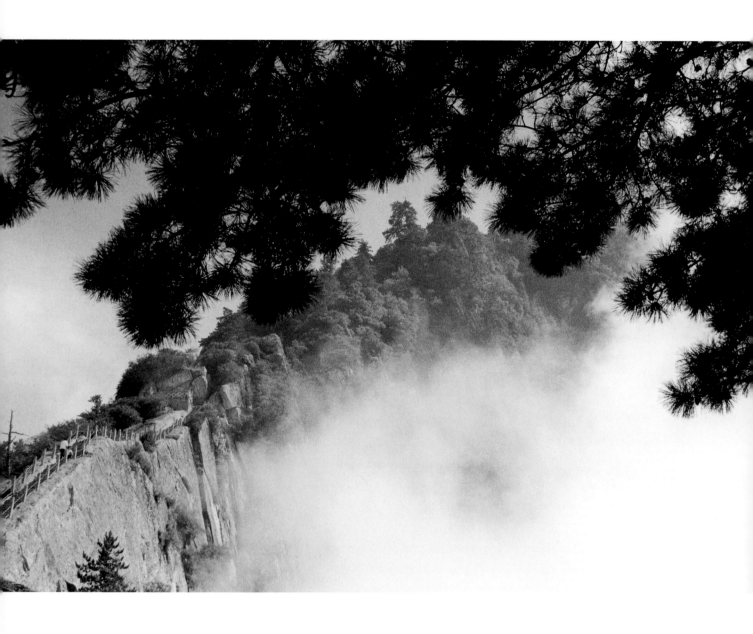

Farewell

WANG WEI

Dismounting to drink
wine with you,
I ask where
you are headed.

You say things
have gone hard for you,
you're going back
to live in the mountains.

Then go,
I'll not ask more,
to the white clouds
unbroken by time.

送別

下馬飲君酒
問君何所之
君言不得意
歸臥南山陲
但去莫復問
白雲無盡時

王維

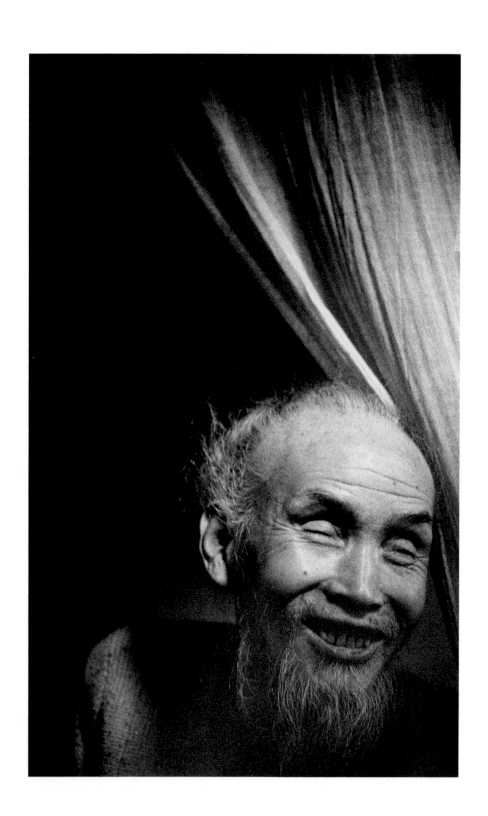

Looking for Ts'ui Cheng, Recluse of Lu Mountain

CH'IU WEI

With the sun high,
the dog and chickens are at rest;
the gate is shut
against the cold pond.

In the evening,
bamboo nearly hides your hut;
the fall garden chills
a stone bed.

You've already lived
years on this mountain,
taking elixirs
for a long, healthy life.

When those who pretend
to have left the floating life
encounter you,
it only adds to their pain.

尋盧山崔徵君　邱為

日高雞犬靜門掩向寒塘
夜竹深茅宇秋亭冷石床
住山年已遠服藥壽偏長虛棄浮生者相逢益自傷

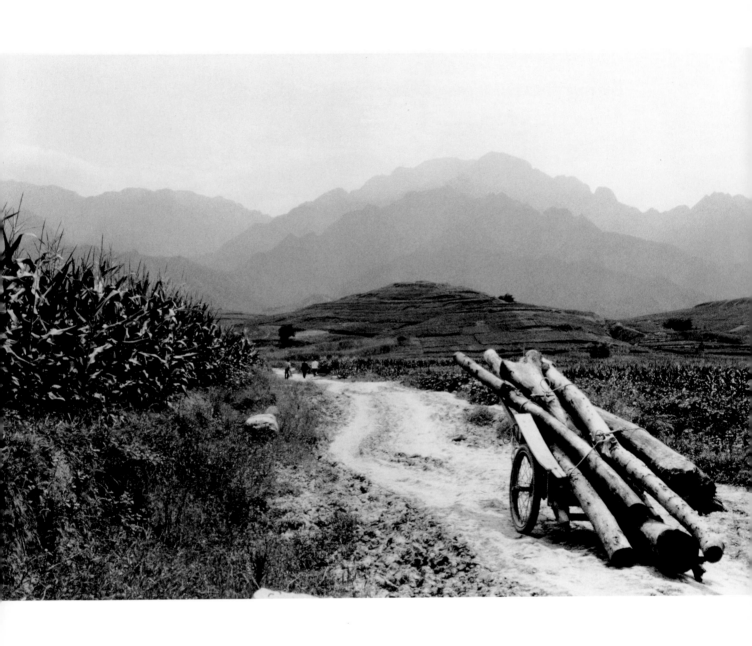

Poem Sent to Brothers and Sisters from the Mountains

WANG WEI

In the mountains
are many companions of the Way,
sitting Zen, chanting,
forming a natural community.

But if you gazed
far off from city walls,
in this direction,
all you would see is white clouds.

山中寄諸弟妹　王維

山中多法侶禪誦自為群城郭遙相望唯應見白雲

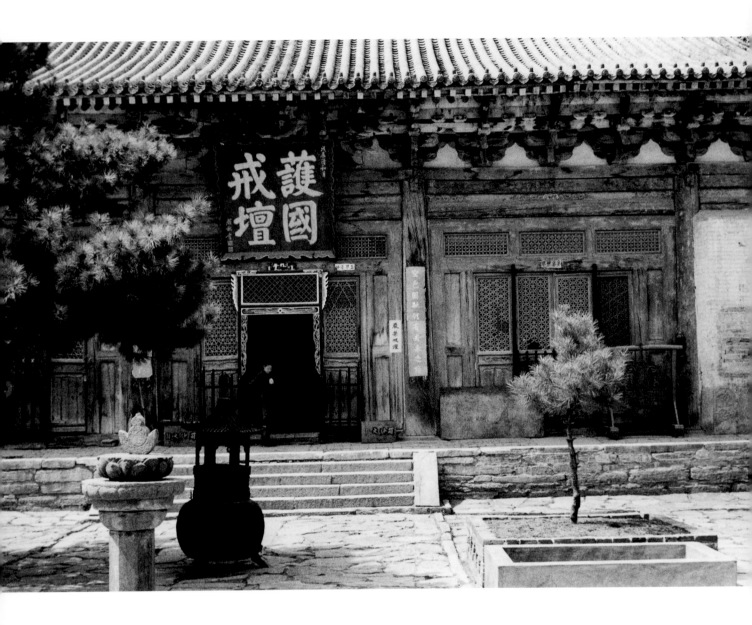

Poem

WANG WEI

You've arrived
from my hometown,
and must know
of its affairs.

When you departed,
was the winter plum
by the silk-framed windows
blooming?

雜詩

君自故鄉來應知故鄉事來日綺窗前寒梅著花未

王維

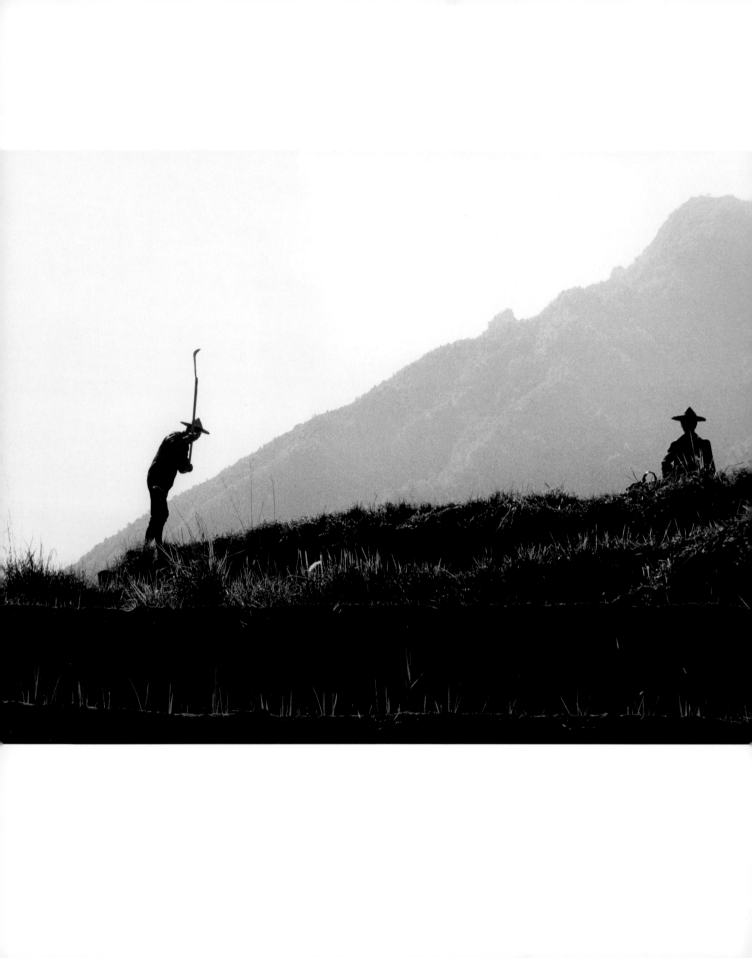

Wei River Farmers

WANG WEI

Late light
shines on the hamlet.

Along worn lanes,
oxen and sheep return.

An old rustic,
thinking of his herdsboy,

leans on his staff
behind the gate.

A pheasant crows
from the flowering wheat;

silkworms lie torpid
among sparse mulberry leaves.

Farmers,
shouldering hoes,

meet and talk,
reluctant to part.

The peace of this life
I envy;

and sadly
sing a song of return.

渭川田家

斜陽照墟落窮巷牛羊歸野老念牧童倚杖候荊扉

雉雊麥苗秀蠶眠桑葉稀田夫荷鋤立相見語依依

即此羨閒逸悵然吟式微

王維

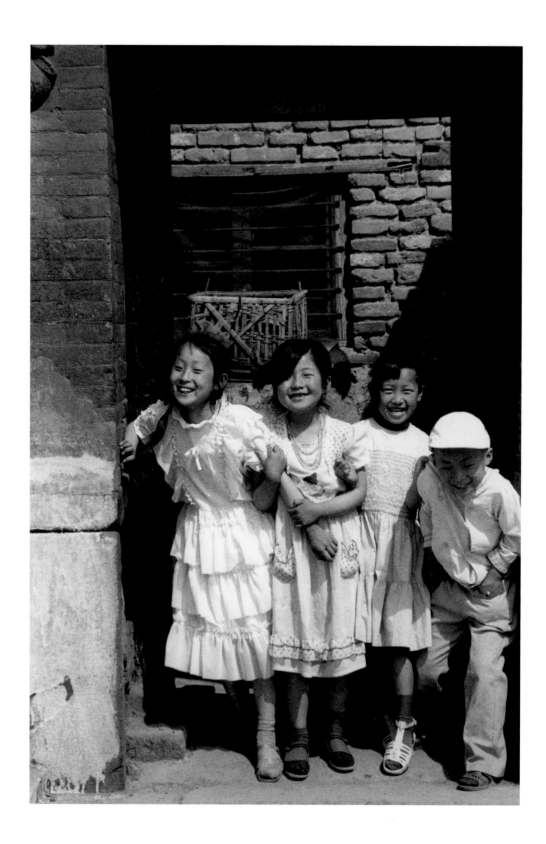

Homecoming

HO CHIH-CHANG

When young I left home,
in old age, returned.

I still speak with a local accent,
but my hair is gray.

Village children greet me,
but can't guess who I am.

They laugh and ask:
"Where do you come from, Sir?"

回鄉偶書

少小離鄉老大回鄉音難改鬢毛衰

兒童相見不相識笑問客從何處來

賀知章

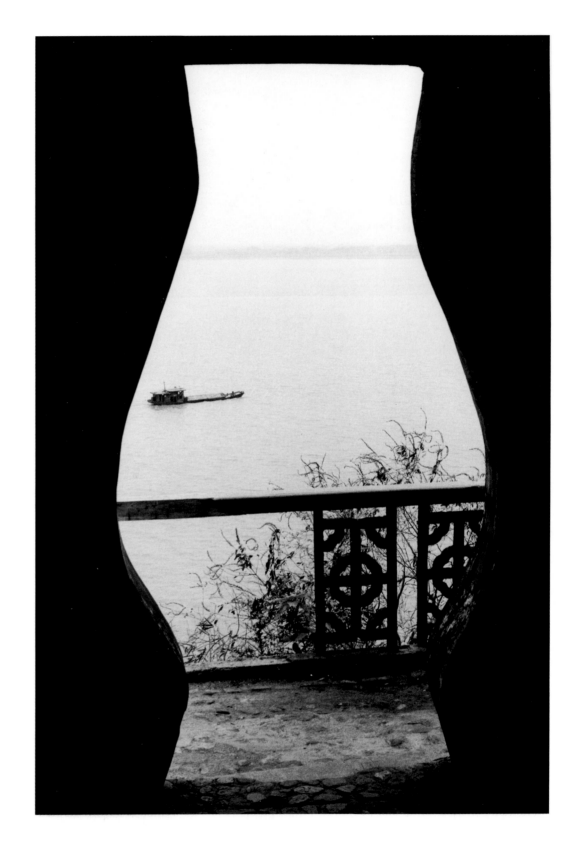

Homecoming (2)

HO CHIH-CHANG

Long ago,
I left my native town;

most recently, my work
has been of small account.

Now, out my door—
only the water of Mirror Lake;

and the spring breeze
rippling its surface, as before.

回鄉偶書二首　賀知章

離別家鄉歲月多近來人事半銷磨

唯有門前鏡湖水春風不改舊時波

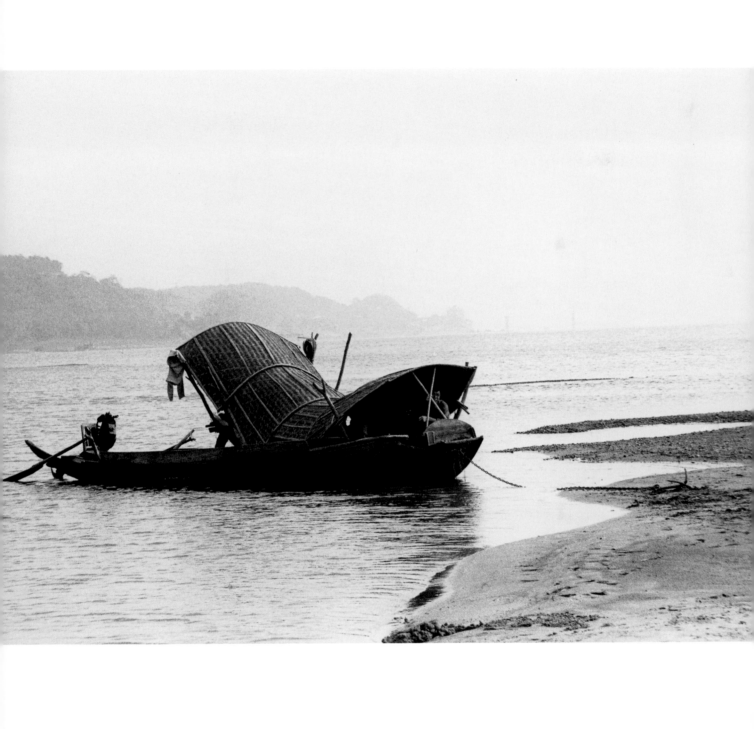

Down to Chiang-ling

LI PO

At dawn I leave
Po-ti in colored clouds;

and make a thousand *li*
to Chiang-ling in a day.

On both banks of the river,
the gibbons' howling never stops;

already my light boat's passed
ten thousand peaks and ridges!

下江陵

朝辭白帝彩雲間千里江陵一日還

李白

兩岸猿聲啼不住輕舟已過萬重山

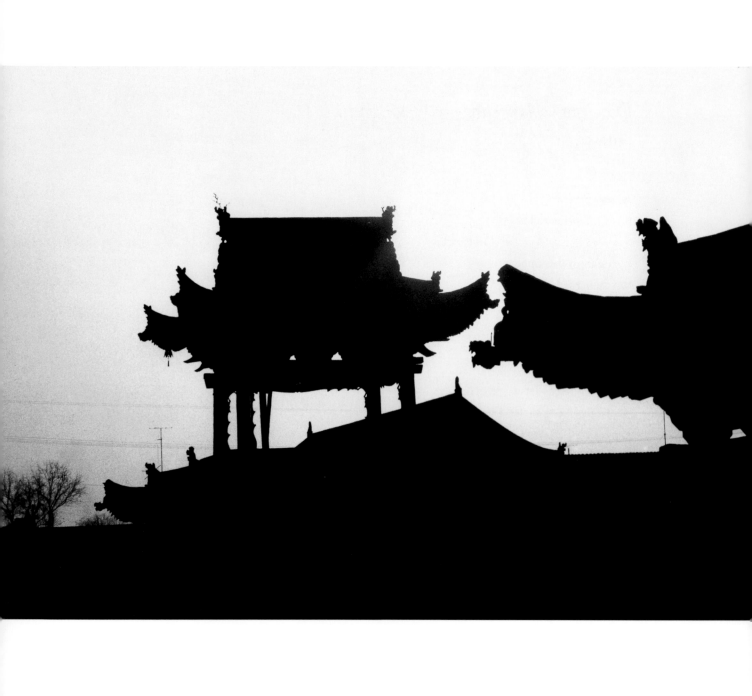

The Monk's Room, Shu-ku Monastery
CH'I-CHI

At a place deep
in green trees,
a lamp's light
burns long.

Spring pilgrims
make their way to the temple;
blossoms fall
at a monk's closed gate.

In the mind,
the ten thousand doctrines are still;
a clear, lone spring
purls over rocks.

We do not ask
about our lives, our work,
and the silence between us
we keep.

書古寺僧房
綠樹深深處長明焰焰燈
萬法心中寂孤泉石上澄勞生莫相問喧默不相應
春時遊寺客花落閉門僧

齊己

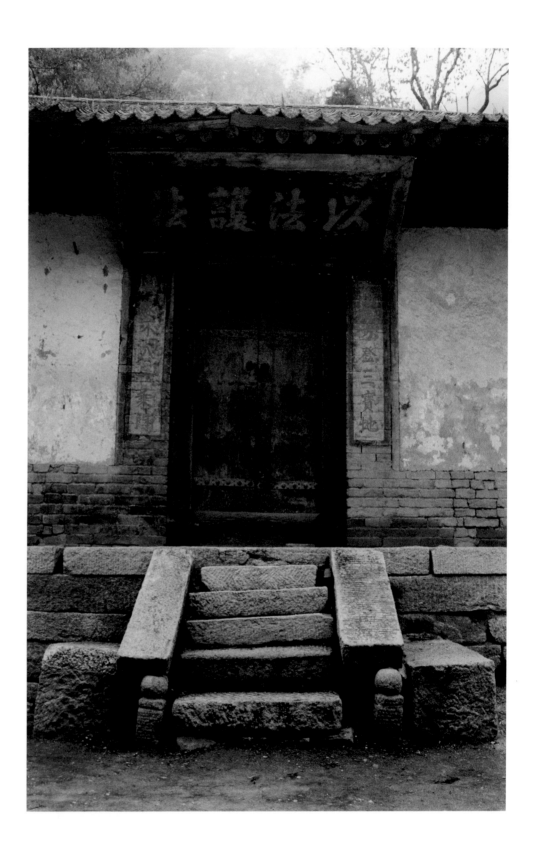

Passing by the Countryside Retreat of Chia Tao

CHANG CHI

You live beyond
the wards of Blue Gate;
walking or sitting,
there's a South Mountain view.

A safe distance
from the general hubbub,
I'm sure you're at peace
when day ends.

Below the fence,
frogs are calling;
grass greens
the entrance to your door.

I'm fond of passing by
your residence;
it's only sad I must return
at dusk alone.

過賈島野居

張籍

青門坊外住　行坐見南山此地去人遠　知君終日閒

蛙聲籬落下　草色戶庭間好是經過處　唯愁暮獨還

69

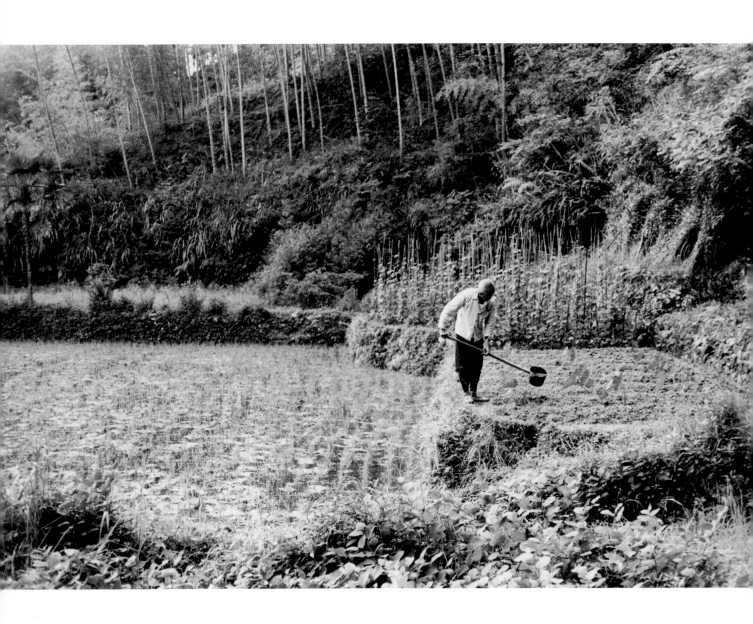

Passing by the Dwelling
of a Cheng Mountain Recluse

LIU CHANG-CH'ING

In the stillness,
a hawk cries
from the apricot trees.

In the deserted
peach orchard,
a dog barks.

I stroll
among fragrant plants
and fallen flowers,

then find—among ten thousand
valleys and a thousand
peaks—your closed door.

過鄭山人所居　　　劉長卿

寂寂孤鶯啼杏園寥寥一犬吠桃源

落花芳草無尋處萬壑千峰獨閉門

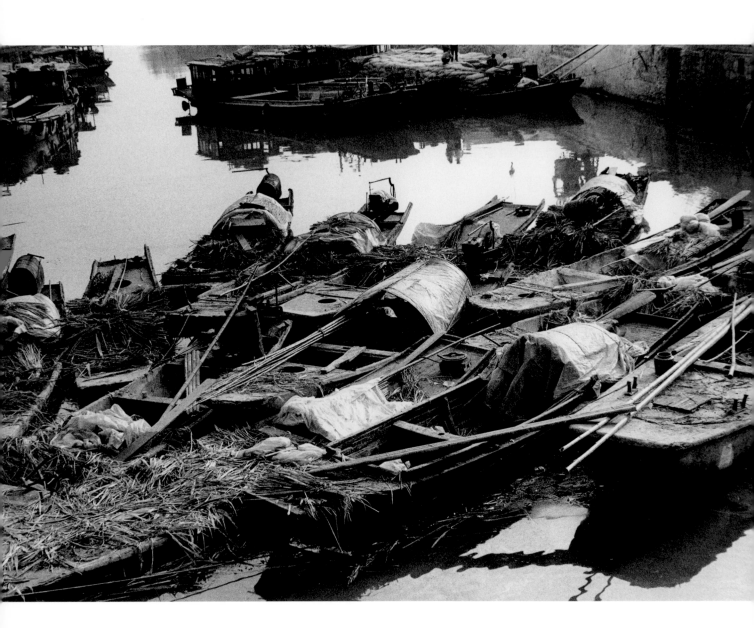

Looking for the Chrysanthemum Lake Master but Not Finding Him

MENG HAO-JAN

When I reach
Chrysanthemum Lake,
the sun's already low
in the village sky.

The Lake Master's gone
climbing the high hills;
there's only a dog, a few chickens,
at an empty house.

尋菊花潭主人不遇　孟浩然

行至菊花潭村西日已斜主人登高去雞犬空在家

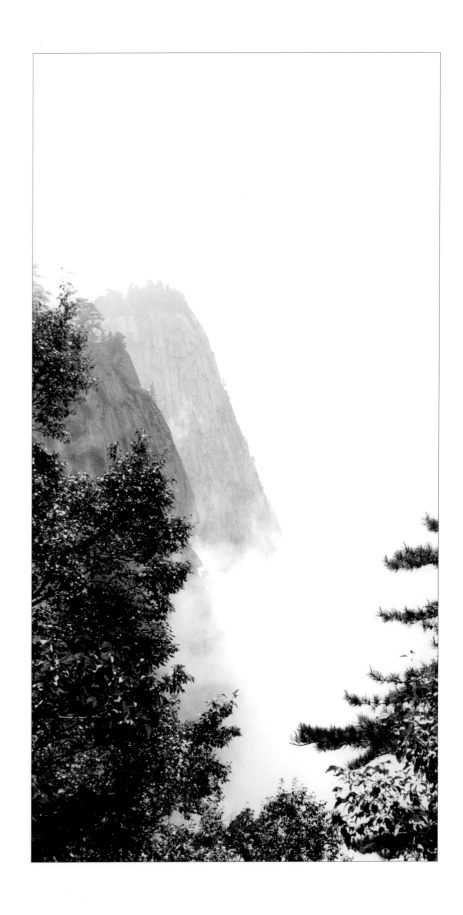

On a Spring Day, Looking for Wang, the Ch'an-River Recluse

MA TAI

The faint path
through green grass
ends.

A door
in white clouds
opens.

Zither strings leave off
where music of the pines
begins.

As I watch,
the river-moon
rises.

During the night,
birds alter
the flower bed;

the woodcutter's son
goes early
to water it.

Brushing off
the green moss
of river rocks,

we sit
together
in the morning dew.

春日尋�川王處士　馬戴
碧草徑微斷白雲扉晚開罷琴松韻發鑒水月光來
宿鳥排花動樵童澆竹迴與君同露坐澗石拂青苔

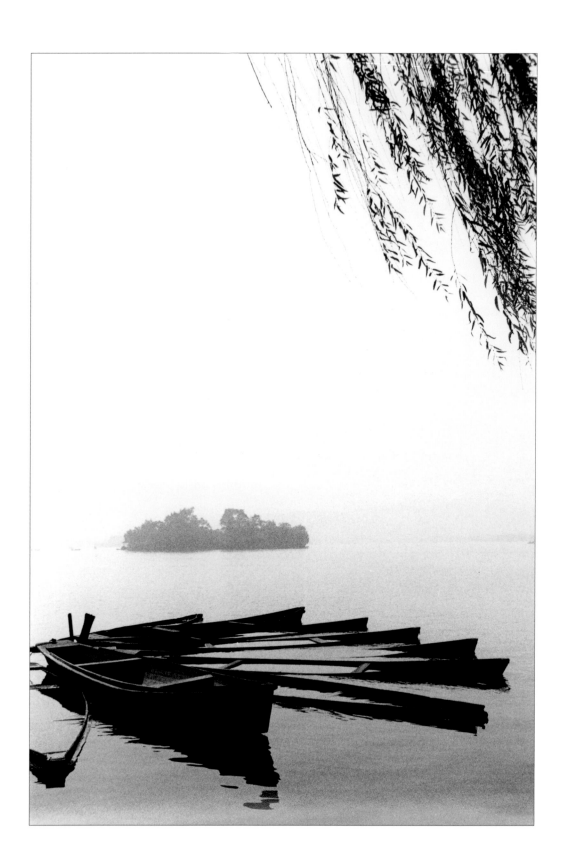

River Snow

LIU TZUNG-YUAN

A thousand mountains—
not one bird flying.

Ten thousand trails—
no sign of human tracks.

One boat with an old man,
in rush hat and rain cape,

alone,
fishing the cold river snow.

江雪

千山鳥飛絕
萬逕人蹤滅
孤舟簑笠翁
獨釣寒江雪

柳宗元

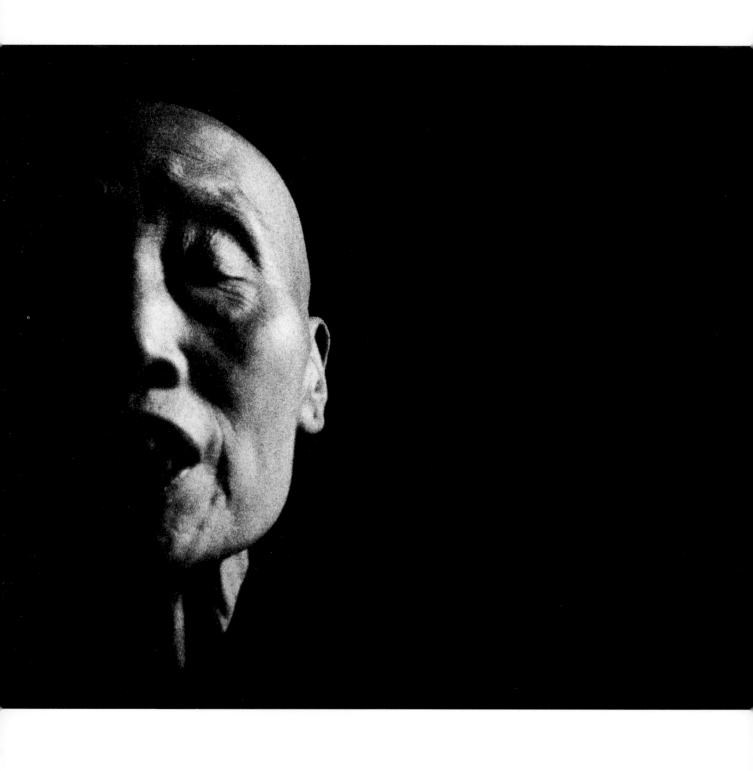

Winter Dusk at a Remote Temple

JEN FAN

Approaching year's end,
east of the river
the weather turns cold.

Lamplit walls
hold
stunted shadows.

At the wilderness temple,
dusk spreads
to river and sky.

Roof tiles
bearing snow
creak constantly.

No wine I know
can melt
this night.

Drifting about in the world,
I still have
a thousand *li* to travel;

I follow a monk,
who shuts
the gates early.

but just now,
I want to lose myself
in the temple's pure chanting of sutras.

冬暮野寺

江東寒近臘野寺水天昏無酒可銷夜隨僧早閉門
照牆燈影短著瓦雪聲繁飄泊仍千里清吟慾斷魂

任翻

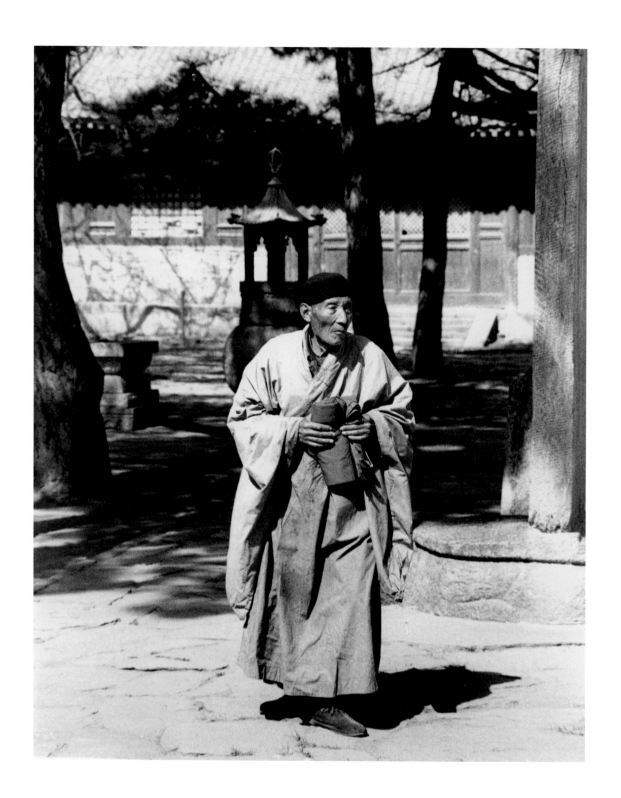

K'ai-sheng Temple

LI SHE

Overnight,
rain begins to pool
in dense underbrush.

Below the temple bell,
a flock of crows flies up,
scatters.

In the long corridor,
nothing transpires—
just a monk heading back to the courtyard.

The whole day,
in front of the temple gate,
I see nothing but pine trees.

題開聖寺

李涉

宿雨初收草木濃群鴉飛散下堂鐘

長廊無事僧歸院盡日門前獨看松

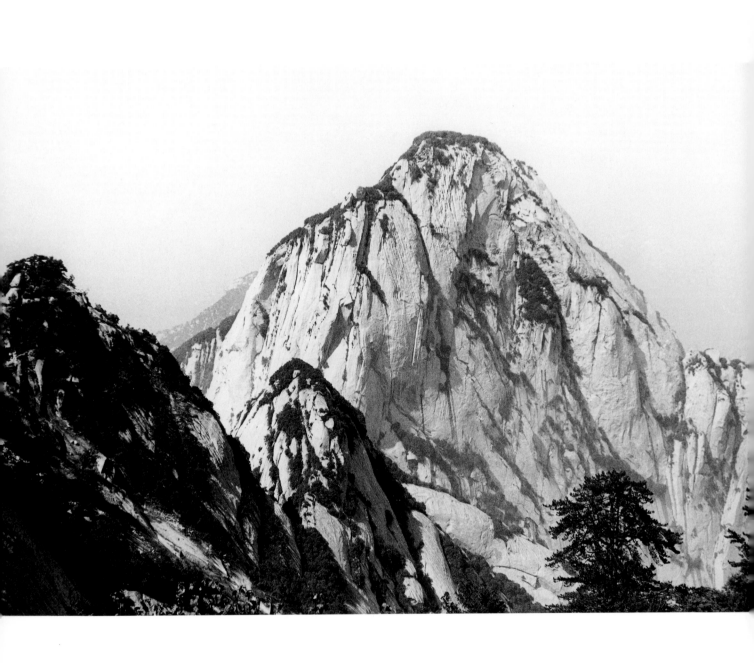

Overnight at the Zen Temple on Chin-tzu Mountain (1)

JEN FAN

In early autumn
on the mountaintop,
the night grows chilly.

Cranes flutter in the pines,
and my robe catches dew
from the branches.

In front of the peak,
the moon casts its light
across the river.

A monk,
in blue mountain mist,
opens his bamboo door.

宿巾子山禪寺　任翻

絕頂新秋生夜涼鶴翻松露滴衣裳

前峰月映半江水僧在翠微開竹房

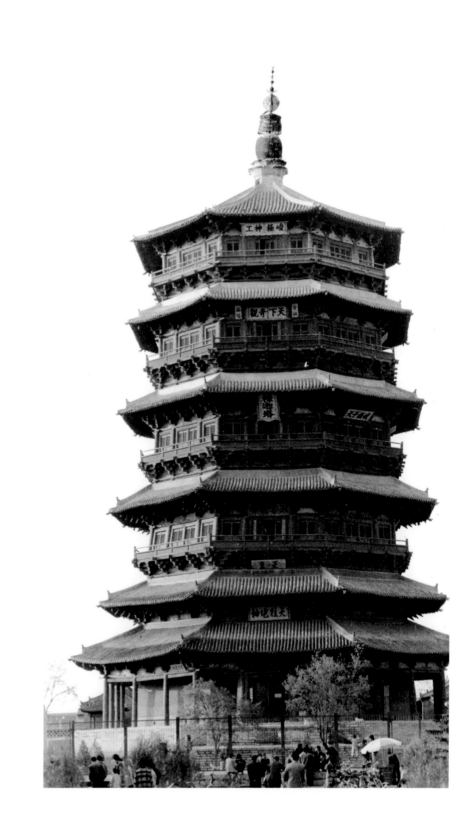

Returning to the Temple on Chin-tzu Mountain (2)

JEN FAN

Cheng-feng temple
perches above
the Ling River.

After thirty years,
I climb again
to its gate.

Wild cranes
still flock
in the pines.

But at the bamboo hut,
I do not find
the old monk.

再遊巾子山寺　任翻

靈江江上憤峰寺三十年來兩度登

野鶴尚巢松樹偏竹房不見舊時僧

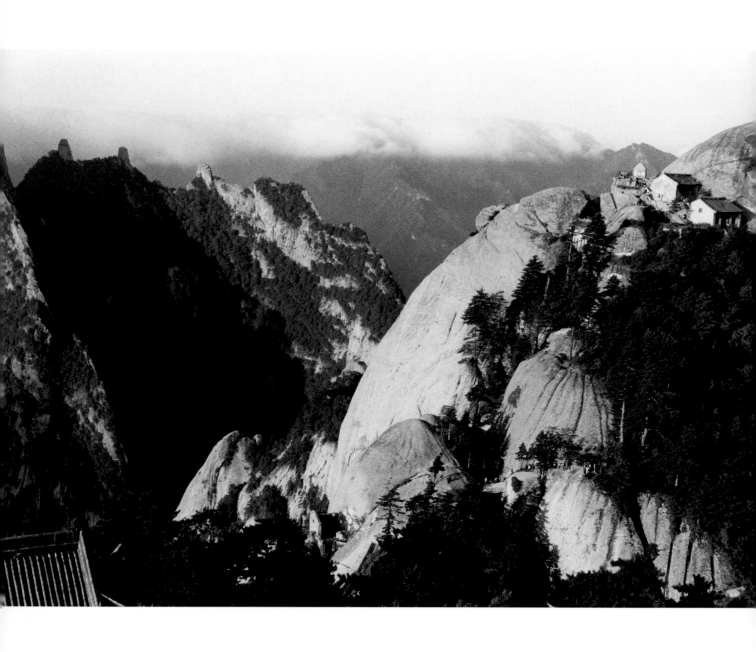

A Third Trip to the Temple
on Chin-tzu Mountain (3)

JEN FAN

On the mountaintop,
in clear autumn weather,
the door of the hut is open.

What year was it
the cranes in the pines flew off,
not to return?

In the depths
of night,
there is still only

bright moonlight
streaming
across the river.

惟有前峰明月在夜深猶過半江來
清秋絕頂竹房開松鶴何年去不迴
三遊巾子山寺感述　任翻

Winter Moon, Rain in Ch'ang-an, Watching the Chung-nan Mountains in Snow

CHIA TAO

The Autumn Festival's
already passed;
in light rain,
snowy peaks emerge.

West Summit
briefly brightens;
the rain, a mere drizzle,
still falls.

The invading cold air
freezes waterfalls,
ices the inside
of white-cloud caves.

This morning,
wild geese on the Pa and Ch'an Rivers.
When will they reach
Hsiao and Hsiang river moonlight?

I think of those hermits
in stone houses,
doors open,
facing the snow.

冬月長安雨中見終南雪　賈島

秋節新已盡雨疏露山雪西峰稍覺明殘滴猶

未絕氣侵瀑布水凍著白雲穴今朝灞滻鴈何

夕瀟湘月想彼石房人對雪扉不閉

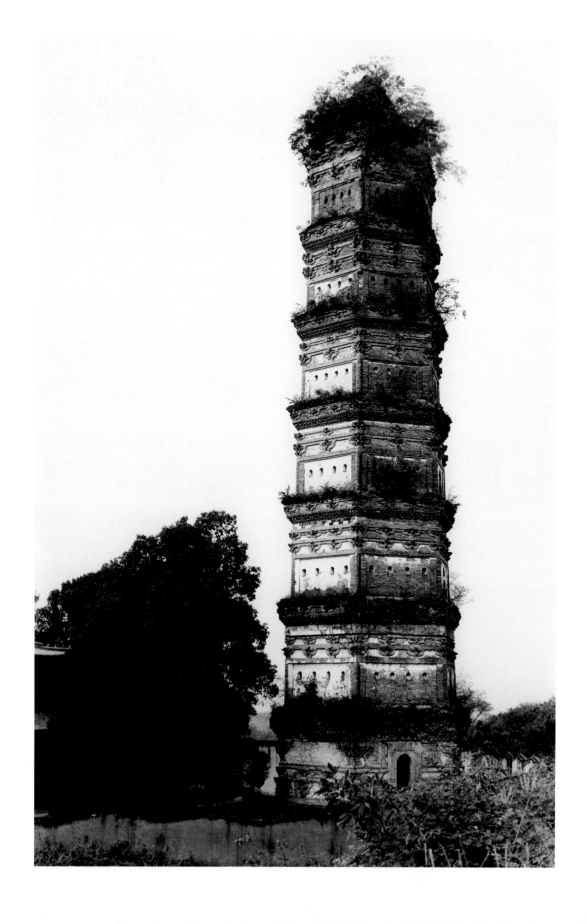

Autumn Night, Thinking of a Tzu-ke Mountain Monk

PAO JUNG

With the whole mountain
colored by rain,
its form is hard to see.

From across the river,
the chanting of sutras
is difficult to hear.

On Tzu-ke Peak,
deep in the night,
many monks enter *samadhi*.

But at the stone tower,
who is sweeping
the autumn clouds?

秋夜懷紫閣峰僧　鮑溶

滿山雨色應難見隔澗經聲又不問

紫閣夜深多入定石臺誰為掃秋雲

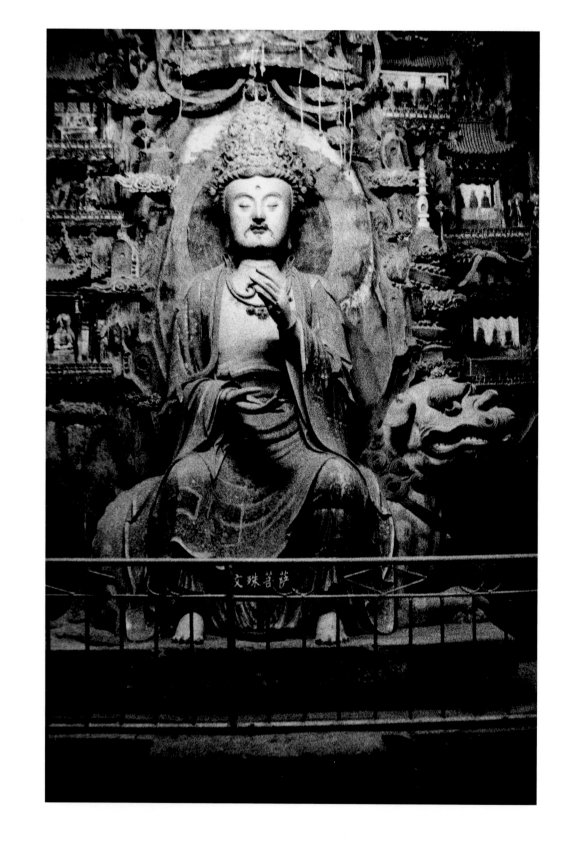

For a Buddhist Monk

CHIA TAO

In a tangle of mountains,
in autumn trees, a cave—
hidden within,
a magic dragon-pearl.

Poplar and cassia
overlook a blue sea;
rare fragrances waft
from a stone pagoda.

A monk since young,
you still have no white hair;
you enter upon meditation
in a frost-streaked robe.

Here there is no talk
of the world's affairs—
those matters that make
wild the hearts of men.

贈僧

亂山秋木穴裡有靈蛇藏
楊桂臨滄海石樓聞異香
出塵頭未白入定衲凝霜
莫話五湖事令人心慾狂

賈島

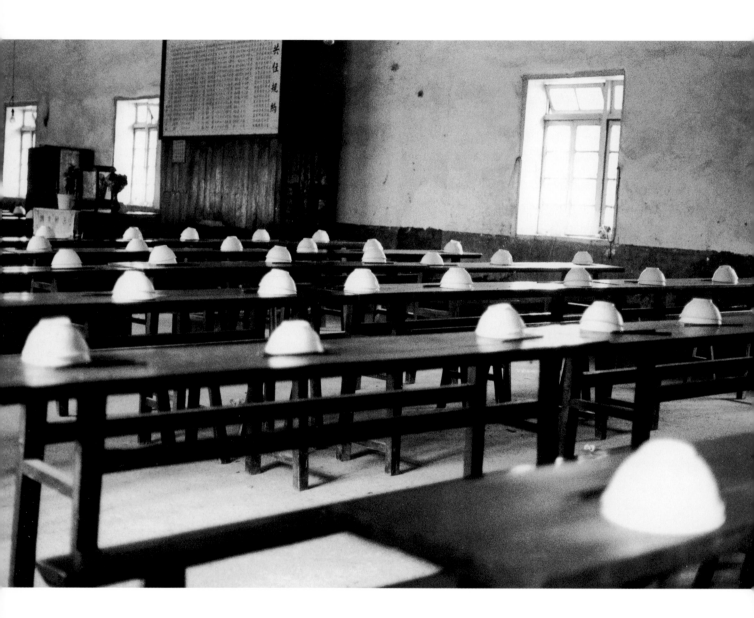

Tasting Tea

CH'I-CHI

Evening smoke rises
from the stone dwelling;
at the window by the pines,
my host grinds an iron pestle.

Because I'm staying over,
I should try a cup;
after all, everyone says:
send monks tea.

The taste awakens
the poetry devil;
the aroma haunts
my sleep.

Spring wind
and thunder on the river;
I well recall that walking trip,
all the green plants on the banks.

嘗茶　　　齊己

石屋晚煙生松窗鐵碾聲因留來客試共說寄僧名

味擊詩魔亂香搜睡思輕春風雲川上憶傍綠叢行

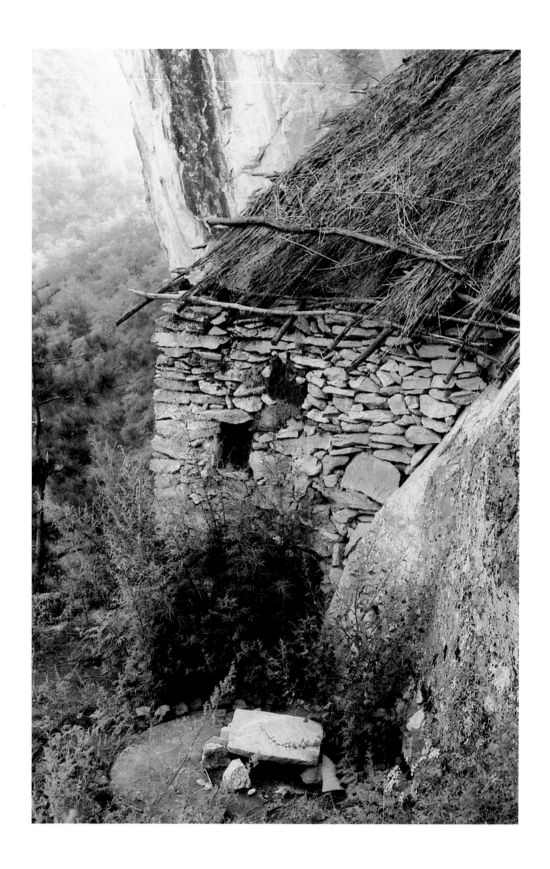

Reclusion, Late Summer

YAO HO

To this place of retreat,
the world does not follow;
but many old ailments
heal here.

I polish words
of old poems;
view mountains,
and sleep outside my hut.

Colored clouds
cross the setting sun;
cicadas ring
in the leaves of trees.

With this
my heart again knows happiness;
and who would have thought it,
without wine or money?

閒居晚夏

姚合

閒居無事擾舊病亦多痊
選字詩中老看山屋外眠
片霞侵落日繁葉咽鳴蟬
對此心還樂誰知乏酒錢

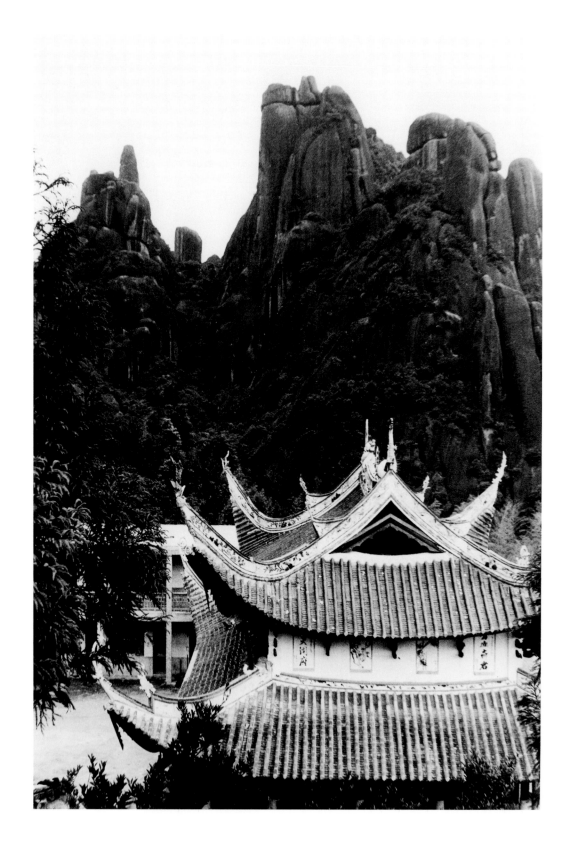

At a Monastery Overnight

SHIH CHIEN-WU

Hearing the bell
while looking for a place to stay,
I enter the mist alone.

Below the cliffs,
a monk, though ill,
still sits in meditation.

Where do the thoughts
of a lonely guest
go?

In the shadows
of autumn clouds,
only one lamp burns.

宿蘭若　施肩吾
聽鐘投宿入孤煙
巖下病僧猶坐禪
獨夜客心何處是
秋雲影裡一燈然

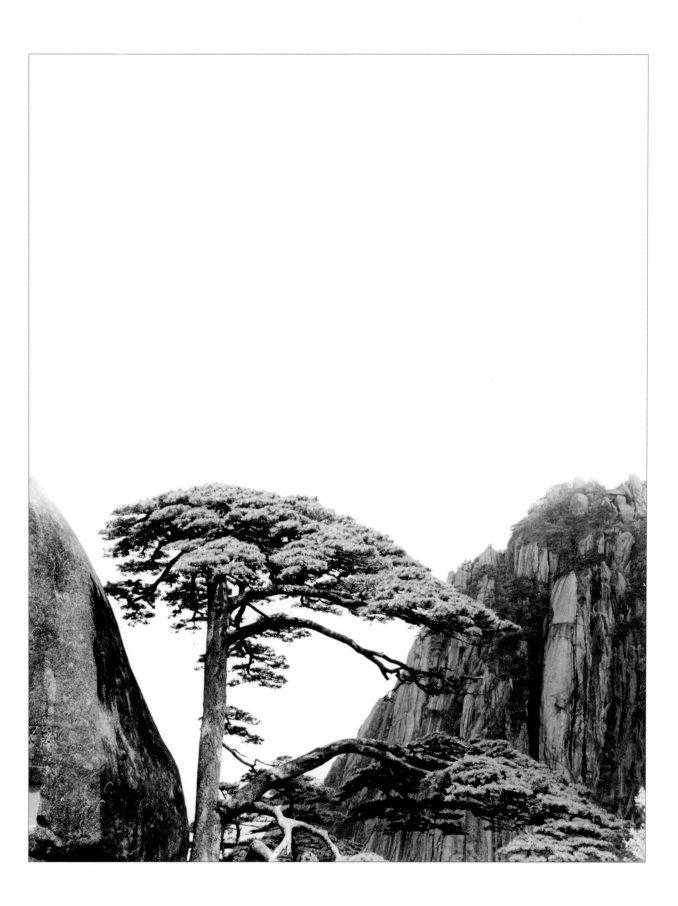

Taoist Master in Mountains

CHIA TAO

You've brushed your hair
a thousand strokes;
but your gaunt face shows
you've stopped eating grain.

You raise crane chicks
to full maturity;
plant seeds
to grow tall pines.

A Taoist concoction simmers
through the night;
a cold stream pounds
through the day.

Never far from this
secluded place,
what people of the world
could ever find you?

山中道士　賈島

頭髮梳千下休糧帶瘦容養雛成大鶴種子作高松

白石通宵煮寒泉盡日春不曾離隱處那得世人逢

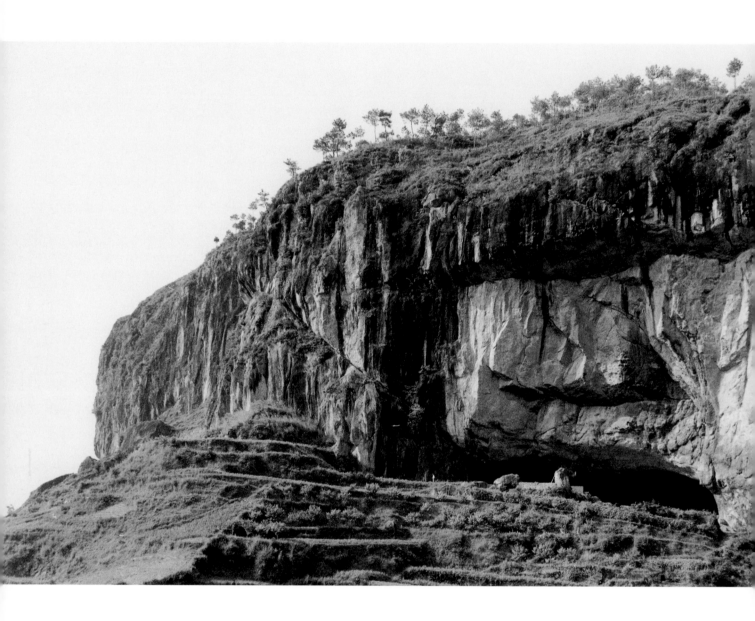

On Hearing a Bell

CHIAO-JAN

From the old temple
on Cold Mountain,
a soft breeze carries
the sound of a far bell.

The tolling subsides
in the stirring of moonlit trees;
dies
in the frost-streaked sky.

In this long night
of Zen meditation,
when the clear bell sounded,
it was my mind.

聞鐘　　　皎然

古寺寒山上遠鐘揚好風聲餘月樹動

響盡霜天空永夜一禪子泠然心境中

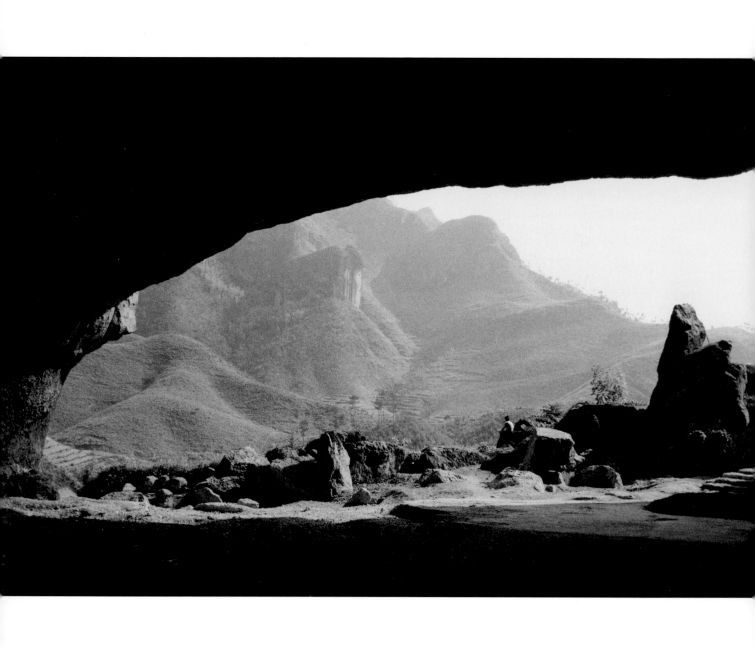

A Thousand Clouds, Ten Thousand Streams

HAN-SHAN

Among a thousand clouds,
ten thousand streams,
there's a man
at ease with it all.

By day,
he wanders the blue slopes;
at night, returns to sleep
below the cliffs.

Springs and autumns
swiftly pass;
by sitting still,
no dust can gather.

Happy,
clinging to nothing;
he's serene
as a river in fall.

寒山

千雲萬水

千雲萬水間中有一閒士白日遊青山夜歸巖下睡

倏爾過春秋寂然無塵累快哉何所依靜若秋江水

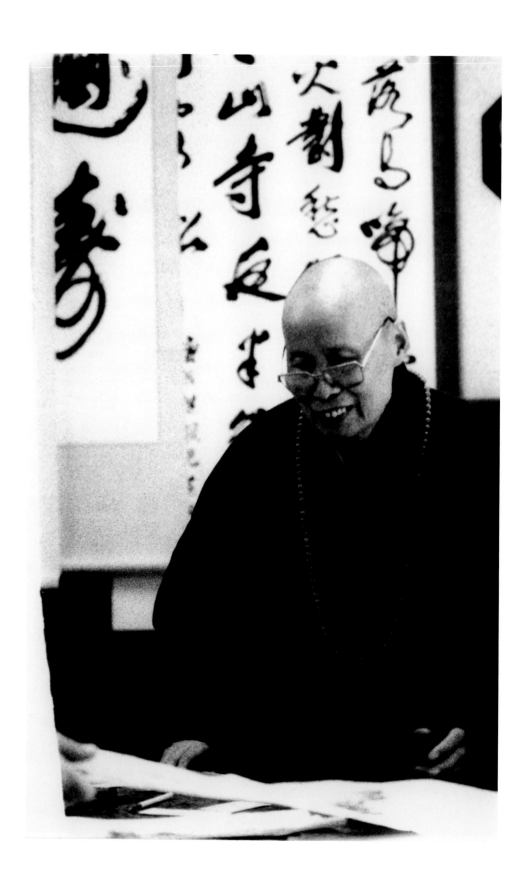

Responding to a Friend

CHANG CHI

Today in warming mountains,
spring pigeons made
their soft low cries.

Following a stream,
I took my time
observing flowers.

Toward evening,
I returned
to under my stone window,

where,
on the leaf of sweet flag,
I found your name.

山中酬人

張籍

山中日暖春鳩鳴逐水看花任意行
向晚歸來石窗下菖蒲葉上見題名

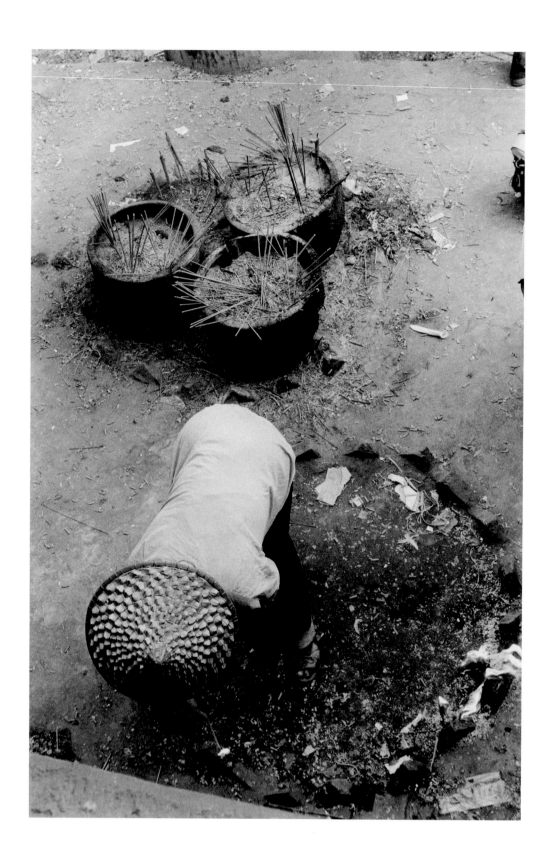

Ch'an Master

CHANG CHI

Year after year,
you've lived alone
atop West Summit—
the door of your stone hut closed.

Without others,
you sit alone in meditation;
when people come,
they light incense.

禪師　張籍

獨在西峰頂年年閉石房
定中無弟子人到為焚香

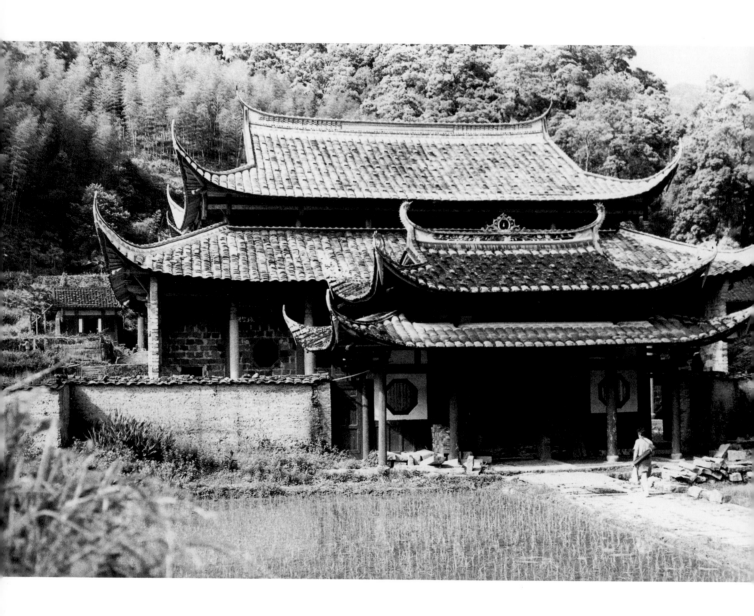

For Monk Wei

LIU CHANG-CH'ING

In blue ephemeral haze,
you come and go
through your Zen gate.

On Yen Mountain,
the view's ten thousand *li,*
a thousand peaks.

When will we
arrive together
in the T'ien-t'ai Range

and be
with the floating clouds
everywhere at ease?

贈微上人　　劉長卿

禪門來往翠微間萬里千峰在剡山

何時共到天台裡身與浮雲處處閒

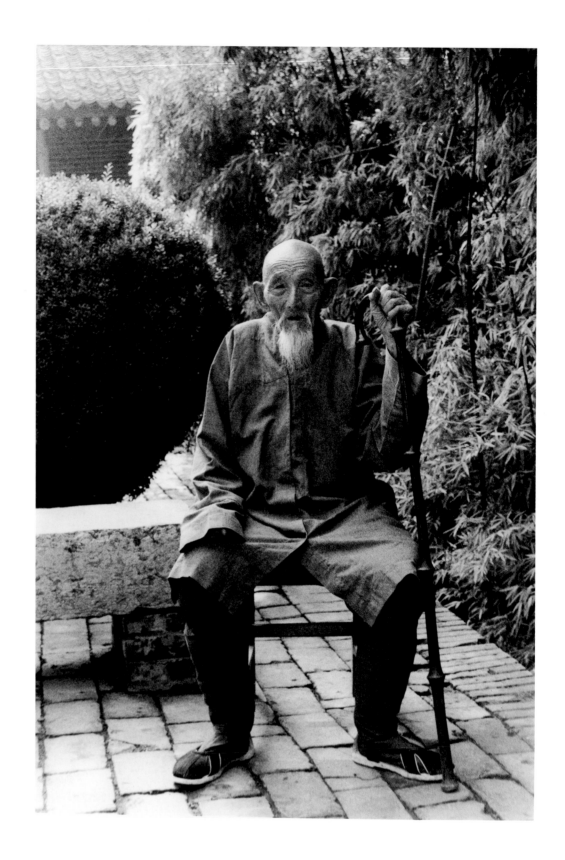

For Monk Hung-ch'uan

CHIA TAO

Under Indigo Mountain,
an old Master
of undiminished spirit,
washes his feet in the stream.

He knows by heart
the plants along the watercourse;
his dwelling's
in an undisturbed jade wood.

West: the temple lamps
and chimes of evening;
east: the windy woods
and rain of dawn.

That old peak, Mount T'ai-po,
is his neighbor,
rain-wet moss,
his stone seat.

贈弘泉上人　　　賈島

洗足下藍嶺古師精進同心知溪卉長居此玉林空

西殿宵燈磬東林曙雨風舊峰鄰太白石座雨苔濛

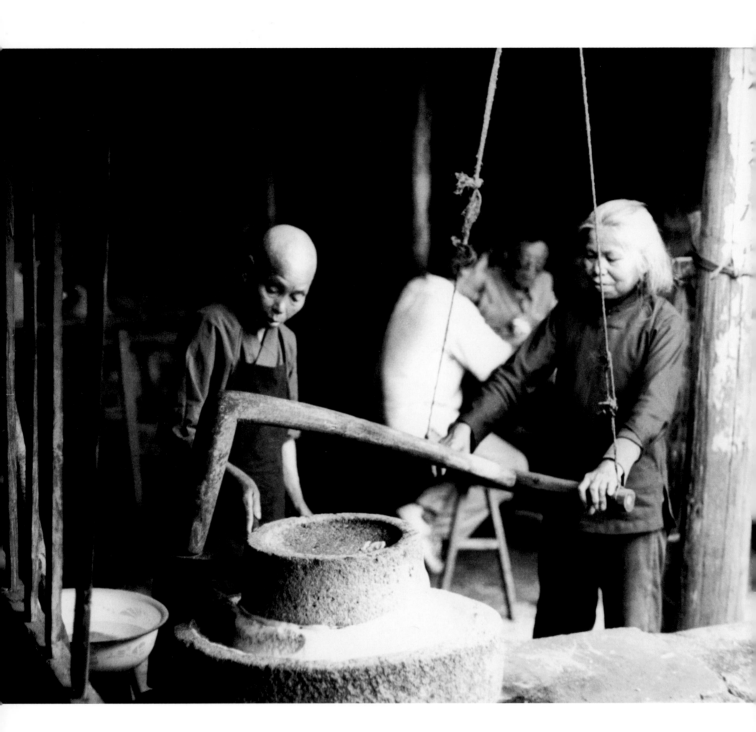

Song of the Pine and Crane

TAI SHU-LUN

Rain soaks
the cold pine shade;
wind scatters
pine-pollen dust.

The lone crane
loves purity and seclusion;
O crane, fly here;
don't fly away.

松鶴

戴叔倫

雨溢松陰涼風落松花細獨鶴愛清幽飛來不飛去

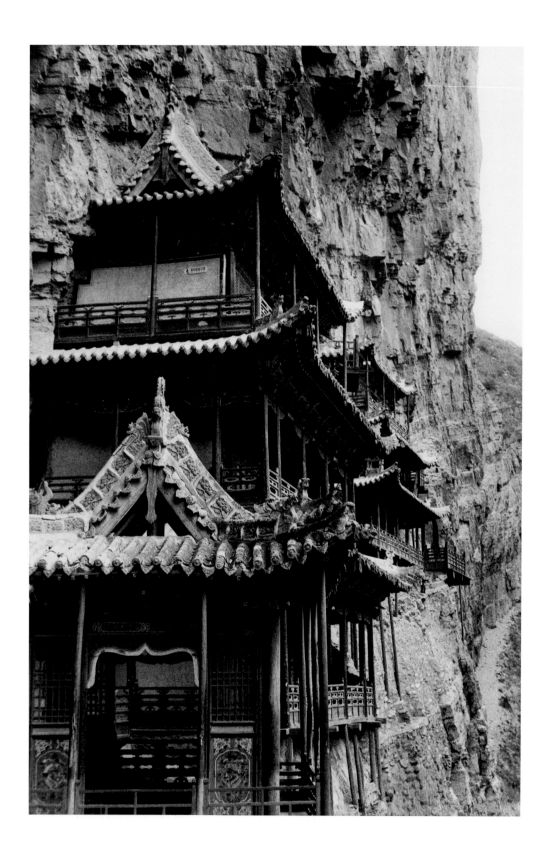

Seeing Off a Buddhist Monk Traveling to Heng Mountain

CHIA TAO

Your heart knows
the way to Heng Mountain;
you are not afraid
few people go there.

Inside the boat,
you still hear birds and temple chimes;
at the river's source,
you dry your monk's robe in the sun.

You had a family,
but left it when young;
now there is no temple
that would not welcome you.

Managing to find
a shelter in the cold,
you do your usual *zazen*
as snow fills up your door.

送僧遊衡嶽　　賈島

心知衡嶽路不怕去人稀船裡猶鳴磬溪頭自曝衣

有家從小別無寺不言歸料得逢寒往當禪雪滿扉

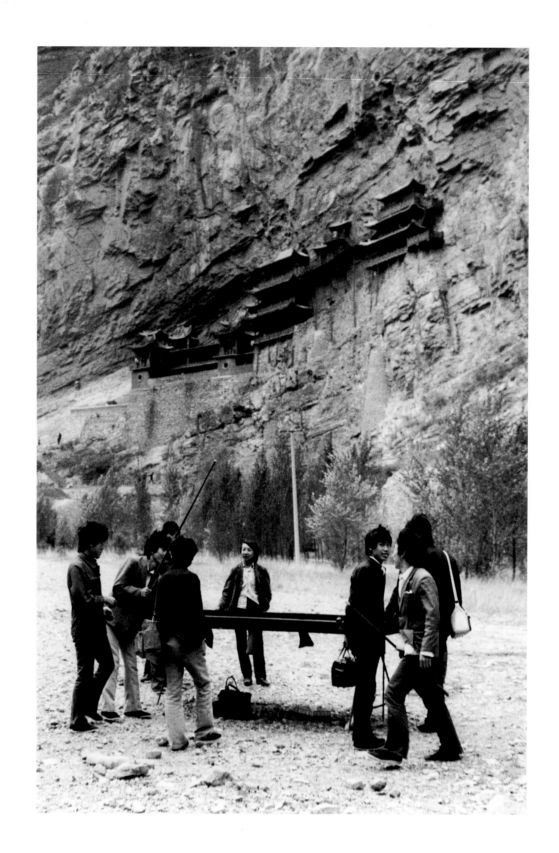

Song of Wei City

WANG WEI

Wei City morning rain
dampens the light dust;

by this inn, green,
newly green, willows.

I urge you to drink
another cup of wine;

west of Yang Pass
are no old friends.

渭城曲

王維

渭城朝雨浥輕塵客舍青青柳色新

勸君更盡一杯酒西出陽關無故人

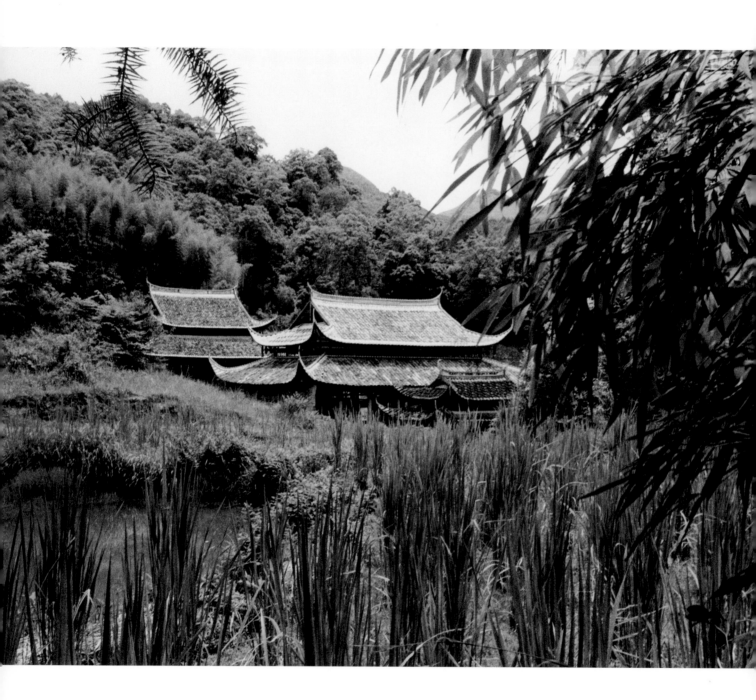

Looking for Ch'an Master Ch'eng at the Monastery

LIU CHANG-CH'ING

Fall grass,
chrysanthemums
cover
the temple paths.

On the far side
of woods,
cook-smoke
is rising from where?

The mountain monk's
alone on old peaks;
and I only meet a youth
in cold pines.

尋盛禪師蘭若

劉長卿

山僧獨在山中老唯有寒松見少年
秋草黃花覆古阡隔林何處起人煙

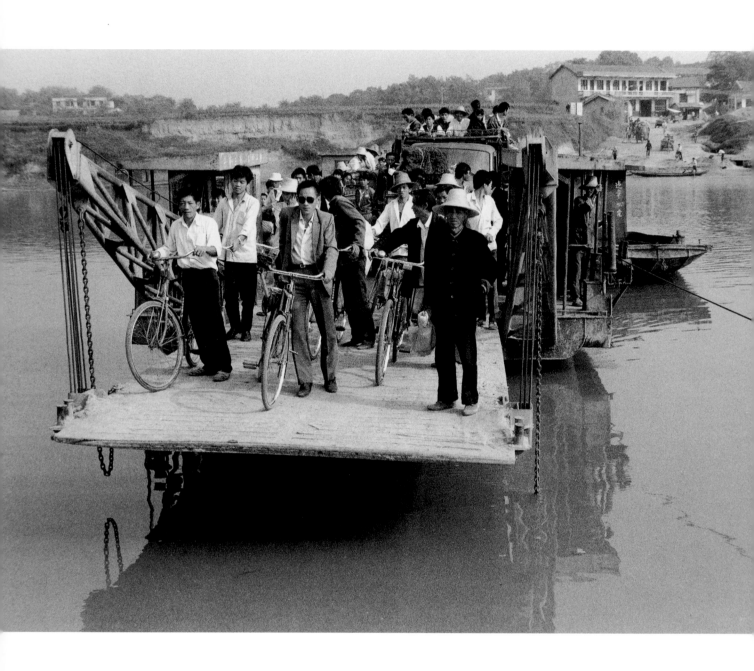

Night, Arriving at a Fisherman's Home

CHANG CHI

The house
dots the river mouth;
tidewater reaches
the brushwood door.

I'm looking for a place
to spend the night,
but the head of the household
hasn't returned.

The bamboo is thick,
and the village road, dark;
the moon rises
on a few fishing boats.

I search about
for a sandbar in the river;
a spring breeze
rustles my frayed clothes.

夜到漁家

漁家在江口潮水入柴扉行客欲投宿主人猶未歸

竹深村路暗月出釣船稀遙見尋沙岸春風動草衣

張籍

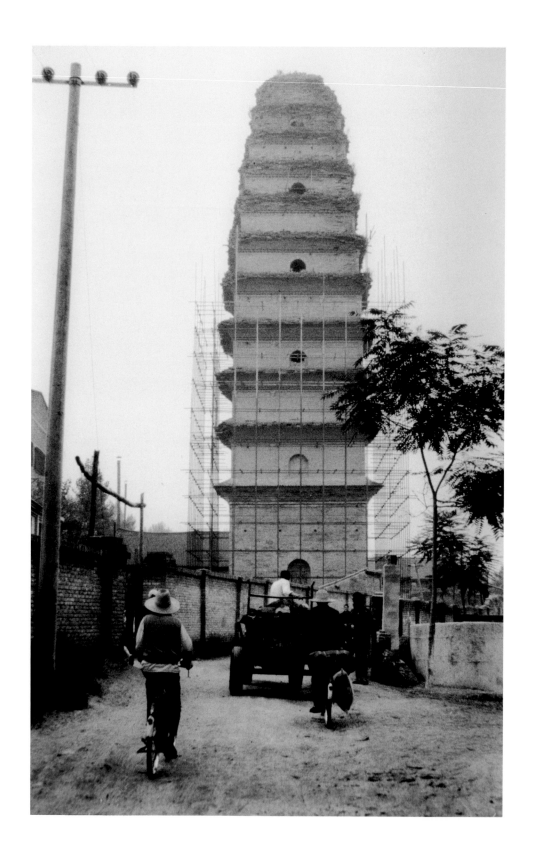

Fa-hsiung Temple, East Pavilion

CHANG CHI

Here at Fen-yang,
where a temple
now stands,

was once a pavilion
for dancing
and singing.

Forty years have passed,
and the horse-drawn carriages
are gone.

At dusk, deep in the alley,
the ancient locust tree
whines with cicadas.

法雄寺東樓

張籍

汾陽舊宅今為寺猶有當時歌舞樓
四十年來車馬絕古槐深巷暮蟬愁

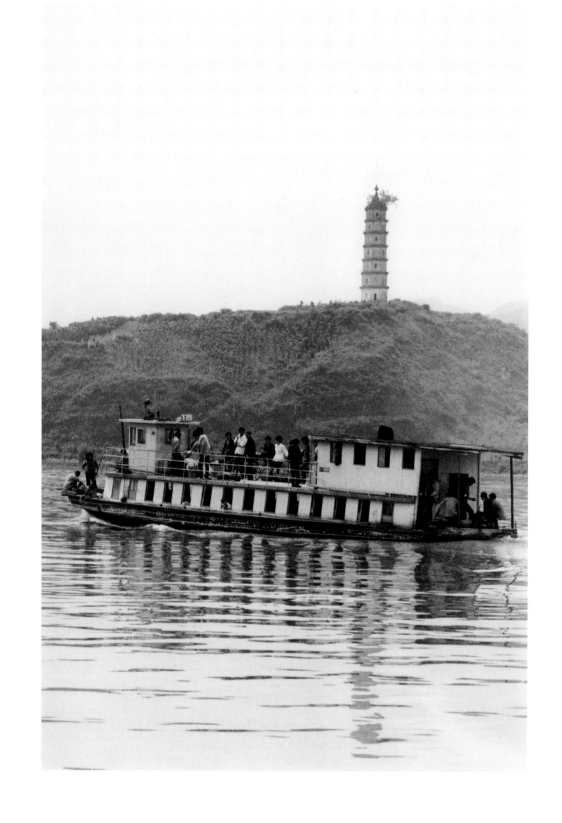

Again Seeing Off Monk Tao-piao

LIU CHANG-CH'ING

Few travel
the thousand *li*
to Heng-yang.

Far off, you follow
a lone cloud
into blue mountain mists.

When spring grass
covers the ground
with green,

you'll come back
through deep mountains
where no roads exist.

重送道標上人

劉長卿

衡陽千里去人稀
遙逐孤雲入翠微
春草青青新覆地
深山無路若為歸

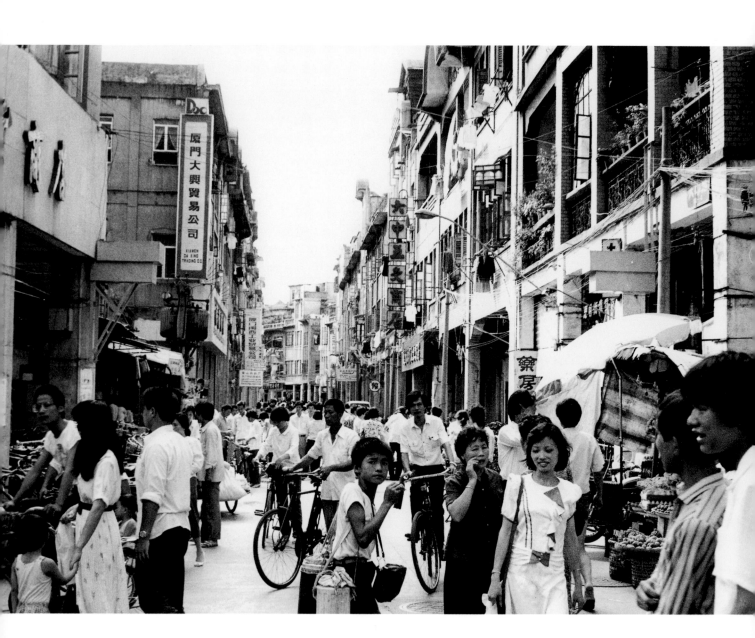

Passing by T'ien-men Street

PO CHU-I

With the snows over
in the Chung-nan Mountains,
spring approaches again.

Distant, moving,
the range's blue jade
meets the world's red dust.

A thousand carriages,
ten thousand horsemen
pass through the Nine Crossroads,

and not one person
turns his head
to see the mountains.

過天門街

白居易

雪盡終南又欲春
遙憐翠色對紅塵
千車萬馬九衢上
回首看山無一人

129

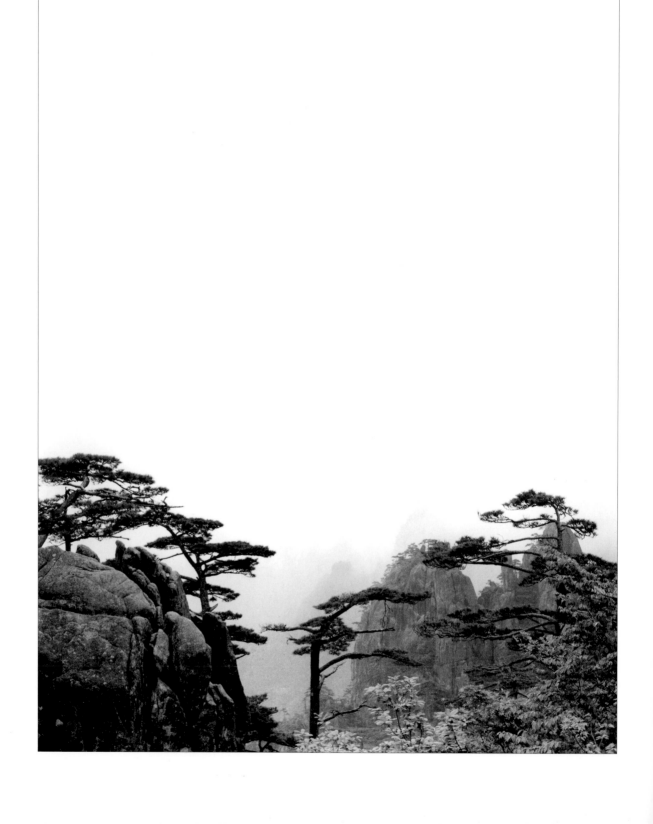

Seeking but Not Finding the Recluse

CHIA TAO

Under pines,
I ask the boy;

he says, "My Master's gone
to gather herbs.

I only know
he's on this mountain,

but the clouds are too deep
to know where."

尋隱者不遇　賈島

松下問童子言師採藥去只在此山中雲深不知處

NOTES

Looking for Immortals, p. 13
West Peak here is likely the West Peak of sacred Hua-shan (Hua Mountain), in ancient times a mountain known for its hermit caves. West Peak, or *a* West Peak, is mentioned in several other poems in this collection. *Immortals: hsien* can refer to mythological beings, shaman-poets, or Taoists who have attained immortality. In this poem, however, and in most of the others presented herein, the word refers to an enlightened individual, or sage, who may be Taoist, Buddhist, a mixture of the two, or non-denominational.

A Chung-nan Mountain Monk, p. 15
The Chung-nan Mountains, some fifteen miles south of the capital Ch'ang-an (today's Xian), divide north and south China. The mountains were the haven for China's shamans-turned-hermits during the early civilizing period of the country. Later, by T'ang times, the mountains had become the place of retreat for large numbers of people, including Buddhists, Taoists, and scholar-officials who might be developing an interest in either Buddhism or Taoism, or simply following the time-honored Confucian tradition of choosing personal virtue over public office.

On Going to See a Taoist Master on Tai-t'ien Mountain but Not Finding Him Home, p. 17
Tai-t'ien Mountain is near the town where Li Po grew up, Ch'ing-lien in Szechuan. The mountain, also known as Ta-kang, was a place of study for the young poet.

Color-of-Nature Gorge, p. 19
Ch'ing (blue, green, black) is known as the "color of nature"—hence the title of this translation. *Chrysanthemum River (Huang-hua Chuan)* is located in Shensi Province. One *li* is approximately a third of a mile.

Farewell to Monk Ho-lan, p. 21
The third stanza is a good example of parallelism in the *lu-shih* form. The monk lives outside the monastic order of things, but writes within the strict demands of classic poetic form. A *cloud* often denotes a monk.

Answer, p. 23
The theme of this poem is an old one: "Out of touch with the world; in touch with the seasons." *Accommodating rock (kao-chen shih)*, or high pillow rock, indicates the recluse is not following the monastic rule forbidding napping or sleeping in comfortable circumstances. The "high pillow" is also a symbol for reclusive life not only lived away from society but beyond the discipline and dogma of organized religion. (See also "Written at Yuan Tan-ch'iu's Mountain Retreat," by Li Po.)

Getting Up in the Night and Viewing the West Garden As the Moon Rises, p. 25
When writing this, the poet was staying at a retreat on the Yu River, southwest of Yung-chou in Hunan Province. He had been banished to the region to serve in a low-level military-affairs position. The poet lived there ten years, and today a small shrine dedicated to him stands along the Yu River.

Upper Cell of Fa-hua Temple—for Monk Ch'an-k'ung, p. 29
The Liang: (the Liang Dynasty), which spanned the years 502 to 556, makes the poem's cassia tree something near 250-years old. The founding emperor of this short-lived dynasty, Emperor Wu, was a strong Buddhist proponent. His legendary meeting with Bodhidharma is recounted in the *Blue Cliff Record: (Pi-yen lu)* (see Ferguson's *Zen's Chinese Heritage*, pp. 16). *Sitting, sit Zen, Zazen, meditation:* I use these terms interchangeably for the practice of Zen meditation.

In Autumn, Dwelling at Fa-hua Temple, Gazing Up at High Peaks from the Courtyard—for Monk Ju-hsien, p. 31
There are at least three temples by the name of *Fa-hua*. This one is probably located in Chekiang. *The Way (Tao)* could be the Taoist or the Buddhist Way. Confucius also used the same character *(tao)* to indicate the Way (of the Mean).

Written at Yuan Tan-ch'iu's Mountain Retreat, p. 35
Tung Mountain (East Mountain) is another name for Sung-shan, the central mountain of the five sacred peaks. It is due south of Lo-yang. *High pillow (kau-chen)* is a symbol of hermit freedom. (See "Answer," by T'ai-shang Yin-che.)

Fasting Taoist Woman, Residing in Mountains, p. 39
Tan (literally, "cinnabar") is the Chinese character used here to indicate alchemy. In Taoist alchemy, cinnabar, which contains mercury, was the major ingredient of elixirs thought to confer immortality.

Written at a Quiet Retreat, p. 41
The "scheme" of the quietist is, of course, to have "no schemes."

Ling-ling Temple, p. 43
Ling-ling Temple is in Shensi Province. The *Odes* and *History (shih-shu)* are the *Book of Odes (Shih-ching)* and the *Book of History (Shu-ching)*; both are among the Five Classics, the most ancient and revered of Chinese texts.

Farewell to a Palace Lady Entering the Way, p. 45
The *Han Dynasty* (206 B.C.–A.D. 7); the Later Han Dynasty (A.D. 25–220). *Colored clouds* refers to Taoist religious attire. The *crane* is a symbol of immortality. *Jade-wheeled (yu-lun)* is a synecdoche for "imperial carriage."

Seeing Off Monk I, p. 47
Willow: (liu) is a traditional symbol of parting.

Farewell, p. 51
The mountains are the Chung-nan Mountains south of the Wei River and Ch'ang-an in Shensi Province. These mountains were, and still are, a favored location for reclusion. *White clouds* are literally the white clouds of the mountains, but they also symbolize the world of recluses and enlightenment. The number of T'ang poems mentioning white clouds is myriad.

Looking for Ts'ui Cheng, Recluse of Lu Mountain, p. 53
Lu Mountain occupies some one hundred and sixty square miles of northern Kiangsu Province. It is famous for its highly changeable cover of clouds and mists. Just to the southwest of the mountain is the native place of the great poet of rustic reclusion, Tao Yuan-ming (365–427). The *floating life (fu-sheng)* has numerous connotations, but here it refers to a life of superfluities and ephemeralness. *Stone bed (shih-chuang)* refers to a stone platform or bench that was used for sleeping and meditation. It was standard furniture for many hermits.

Poem, p. 57
This poem is the second of a set of three miscellaneous poems. My translation is dedicated to the Northwest poet, translator, musician, and calligrapher Robert Sund (1929–2001), who shared with Wang Wei a talent for several arts and a warm poetic sensibility.

Wei River Farmers, p.59
Wei River flows just north of the capital, Ch'ang-an, and enters the Yellow River. The *song of return* is the ode *Shih-wei* ("In Decline") from the *Book of Songs (Shih-ching)*, which recounts the pleading of officers to their lord to return to their native state. As refugees, they protest that circumstances have become unbearable.

Homecoming, p. 61
This poem is the first of a pair. Ho Chih-chang (659–744), a native of Kuei-chi, near Hangchou, Chekiang Province, returned to his home after many years of writing poetry and engaging in officialdom in the capital. He came home to become a Taoist hermit and died soon after.

Down to Chiang-ling, p. 65
In this song, *Li Po* is sailing down through the famed Yangtze River Gorges to join his wife's family at Chiang-ling. The cries of *gibbons*, normally interpreted as sad, are welcomed here as a sign the poet is approaching home.

The Monk's Room, Shu-ku Monastery, p. 67
The ten thousand doctrines (*wan-fa*) refers to religious rules, precepts, principles, etc., that can be in some instances as entangling to a monk seeking enlightenment as the ten thousand affairs (*wan-shih*) or ten thousand things (*wan-wu*) of the material world.

Passing by the Countryside Retreat of Chia Tao, p. 69
Chia Tao: the poet (779–843, also anthologized here). *Blue Gate* was the southeastern gate in Ch'ang-an's city wall during Han times. Later, when the gate ceased to exist, reference to it implied the capital and the capital's political life. *South Mountain*, south of Ch'ang-an in south-central Shensi Province, is part of the Chung-nan Mountain Range. The mountain, which had special meaning for those in and around the capital, is mentioned frequently in T'ang poems.

Passing by the Dwelling of a Cheng Mountain Recluse, p. 71
Cheng Mountain is possibly the name of a peak in the old state of Cheng (Warring States period [403–221 B.C.]), now part of Hunan Province.

On a Spring Day, Looking for Wang, the Ch'an-River Recluse, p. 75
The *Ch'an River* flows out of the Chung-nan Mountains into the Pa River, which is a tributary of the Wei River in Shensi Province.

River Snow, p. 77
This is a classic in Chinese poetry, which every literate Chinese school child can recite.

K'ai-sheng Temple, p. 81
K'ai-sheng Temple was built in the Sung Dynasty just outside West Flower Gate of Kai-feng City to accommodate a special statue of Buddha. It is possible that a smaller, older temple of the same name once existed on that site.

Overnight at the Zen Temple on Chin-tzu Mountain (1), p. 83
Chin-tzu Mountain was presumably in Chekiang Province near Hang-chou. A late-eighth-century monk named Chin-tzu had a small hut on a mountain near Hang-chou, and it is conjectured that his presence there gave the mountain its name. Jen Fan might have been speaking of this hermit in this set of three poems.

Winter Moon, Rain in Ch'ang-an, Watching the Chung-nan Mountains in Snow, p. 89
Autumn Festival (*Ch'iu-chieh*) refers to either Moon Festival or Double Nine (the mountain-climbing festival). Since it comes later in the year, I suspect this reference is to Double Nine. On the other hand, *ch'iu-chieh* could mean autumn of the solar calendar, with the first day of winter (*li-tung*) arriving in early November. The Pa and Ch'an Rivers are in the vicinity of the capital, Ch'ang-an. The Hsiao and Hsiang Rivers are far to the south, in Hunan Province.

Autumn Night, Thinking of a Tzu-ke Mountain Monk, p. 91
Tzu-ke Mountain (or "Purple Pavilion Peak") is south of Xian and close to both White Pavilion (*Pai-ke*) and Yellow Pavilion (*Huang-ko*) peaks. This area, dotted with temples, was a popular location for retreat. *Samadhi* is a deep state of meditation.

For a Buddhist Monk, p. 93
The *magic dragon-pearl* is a symbol of enlightenment. Depending on the variant characters in the texts of Chia Tao's poems—and there are many—one could translate any number of lines differently. The first two lines of the second stanza, for instance, could be translated (rather flatly): "A Buddhist staff / hangs from an overlook to the sea." The last two lines are possibly related to verse 12 of Lao Tzu's *Tao-te-ching*.

Tasting Tea, p. 95
The term *poetry devil (shih-ma)* is thought to have been coined by the poet Po Chu-i, who at times expressed concern that literary activity might interfere with one's path to being a good Buddhist. In the Theravada branch of Buddhism, the precepts do forbid engagement in literary endeavors, and though no such precept exists in the Mahayana (the largest branch with which Chinese monks were affiliated), the Mahayana sects tended to follow the Theravada precept. With the flourishing of Zen and the rise of the poet-monks *(shih-t'seng)*, such as Chia Tao, Kuang-hsuan, Chiao-jan, and Ch'i-chi in the Mid-T'ang Dynasty, the concern over the issue of the poetry devil subsided. (For a fuller discussion of the issue of the poetry devil in Buddhism during the T'ang Dynasty, see Burton Watson's "Buddhist Poet-Priests of the T'ang," in the *Eastern Buddhist* 25.2 (1992): 30–58.

Reclusion, Late Summer, p. 97
Yao Ho was a poet who occupied relatively high official positions. From time to time, influenced by seclusion-loving poet-friends, such as Chia Tao and Wu-k'o, he sought out places of retreat.

Taoist Master in Mountains, p. 101
The act of brushing one's hair suggests both daily ritual and a concern for grooming despite the retreat to wilderness. *Taoist concoction* (literally "white rocks,") is the fare of recluses. In translating, I chose the word concoction to hint at alchemy or pharmacology, which included minerals as well as herbs.

On Hearing a Bell, p. 103
Cold Mountain: This might be the famous Cold Mountain—home of the hermit-poet Han-shan (Mid-T'ang Dynasty)—in the T'ien-t'ai Mountains.

A Thousand Clouds, Ten Thousand Streams, p. 105
Dust: (ch'en) refers to dust of the world, and by extension, worldly cares.

Responding to a Friend, p. 107
This poem is a response to the poet's friend leaving his impromptu "calling card": his ink-brushed name on a leaf of *sweet flag, Acorrus calamus,* a long-leaved herb.

For Monk Wei, p. 111
Yen Mountain and the *T'ien-t'ai Range* are in Chekiang Province. In that range, the famous hermit-poet Han-shan (Mid-T'ang) had his cave. Another resident of the T'ien-t'ai Mountains was Chih-i (538–597), the true founder of the Lotus School, whose principal text is the *Saddharmapundarika Sutra* (the "White Lotus of the True Law Sutra").

For Monk Hung-ch'uan, p. 113
Indigo Mountain is possibly Lan-t'ien Mountain. *Jade wood (yu-lin)* denotes beautiful woods. *Mount T'ai-po* is in southeast Mei County, Shensi Province, about one hundred miles west of Xian. It has a rugged, gnarly rock column for a peak.

Song of the Pine and Crane, p. 115
The *pine* and the *crane* are both symbols of immortality.

Seeing Off a Buddhist Monk Traveling to Heng Mountain, p. 117
Heng Mountain is in Hunan Province. There are two sacred Heng mountains—one in the north and one in the south—written with different Chinese characters. The southern one (in this poem) was the site of Nan-yueh Monastery, from which came Hui-ssu, the Second Patriarch of the Buddhist T'ien-t'ai sect, as well as Shih-t'ou, the patriarch of the Ts'ao-tung, or Soto, Zen sect. *Temple chimes (ch'ing)* consist of pieces of flat, sonorous stone or metal and were used as gongs in Buddhist temples, or for musical percussion. They were especially used to bring meditators delicately out of deep meditation. (A bell was thought to be too abrupt and harsh.)

Song of Wei City, p. 119
Another title for this poem is "Seeing Off Yuan-erh, Envoy to Anhsi." Anhsi, far to the west, was at the time a frontier outpost threatened by invasion from the north. Yang Pass *(Yang-kuan)* was the last pass separating friendly territory from Anhsi. *Wei City* is in Shensi Province.

Looking for Ch'an Master Ch'eng at the Monastery, p. 121
The *youth* is presumably the mountain monk's disciple.

Night, Arriving at a Fisherman's Home, p. 123
Frayed clothes derives from the Chinese *ts'ao-i* (literally, "clothes made from grass"). *Ts'ao-i* also means, by extension, a recluse.

Fa-hsiung Temple, East Pavilion, p. 125
Fen-yang is located in Shansi Province.

Again Seeing Off Monk Tao-piao, p. 127
Heng-yang is a city in Hunan Province.

Passing by T'ien-men Street, p. 129
Red dust (hung-ch'en) is a Buddhist term referring to the world of the senses. Outside of a Buddhist context, it can mean "the mundane world." *Nine Crossroads (chiu-ch'u)* is the collective name of the crossroads of the capital Ch'ang-an, said to lead to everywhere in the world.

Seeking but Not Finding the Recluse, p. 131
This famous, much anthologized, and oft-translated poem has been said by commentators to evoke in its mere twenty syllables the quintessence of China's eremitic tradition.

BIBLIOGRAPHY

TEXTS

Texts for the Chinese poems in this volume are from:

P'eng Ting-ch'iu (1645–1719), ed. *Ch'uan T'ang-shih.* [The Complete Poems of the T'ang] Taipei: Hungyeh Book Company, 1982.

The Chinese text of the Chia Tao poems is from:

O'Connor, Mike. *When I Find You Again, It Will Be in Mountains.* Boston: Wisdom Publications, 2000.

The Chinese text of the above is a recension incorporating choices of variants from the *Ch'uan T'ang-shih* and the four editions of Chia Tao's poetry below:

Ch'ang-chiang chi. *Ssu-pu pei-yao.* Shanghai: Chung-hua shu-chu, 1927–1936; rpt. Taipei: China Book Company, 1966.

Chang, Yu-ming, *Ch'ang-chiang chi chiao-chu.* M.A. thesis, Kuo-li Shih-fan Ta-hsueh, Taipei: 1969.

Ch'en, Yen-chieh, annotator, and Wang, Yun-wu, ed. *Chia Tao shih-chu.* Shanghai: Shang-wu yin-shu-kuan, 1937.

Hsu, Sung-po, ed. *Lu sheng-chih chi, Ch'ang-chiang chi ho-t'ing-pen.* Taipei: Hsinan Book Company, 1973.

ADDITIONAL CHINESE TEXTS AND COMMENTARIES CONSULTED

Chao, Tien-cheng. *Wang Mo chieh-chu'an chi-chu* [Wang Wei Complete Poems] Taipei: Shih-chieh Shu, 1974.

Ch'iu hsieh-you, commentator. *T'ang-shih san-pai shou.* [Three Hundred Poems of the T'ang] Taipei: San-min shu-chu, 1973.

Chung-kuo li-tai ts'eng shih ch'uan chi pien-chi wei-yuan hui, editor. *Chung-kuo li-tai ts'eng shih ch'uan chi: sui, t'ang, wu-tai chuan.* Three vols. [Complete Poems of Chinese Buddhist Monks through the Ages: The Sui, T'ang, and Five Dynasties.] Beijing: Tang-tai chung- kuo, 1997.

Liu Kai-yang. *T'ang-shih t'ung-luan.* [On T'ang Poetry] Taipei: Mu-to ch'u-pan she, 1983.

Tu Sung-po, ed. and annotator. *Ch'an-shih san-pai shou.* [Three Hundred Ch'an Poems] Taipei: Li-ming wen-hau shih-yeh, 1981.

SELECTED REFERENCES

Bary, Wm. Theodore de, ed. *Sources of Chinese Tradition.* New York: Columbia University Press, 1960.

Bynner, Witter, and Kiang Kang-hu. *The Jade Mountain.* New York: Knopf, 1929. Rpt. New York: Doubleday Anchor Books, 1964.

Chang, Ch'i-yun, ed. *The Encyclopedic Dictionary of the Chinese Language.* Taipei: Chinese Culture University, 1973.

Ch'en, Shou-yi. *Chinese Literature.* New York: Ronald Press, 1961.

Ferguson, Andy. *Zen's Chinese Heritage.* Boston: Wisdom Publications, 2000.

Graham, A.C., trans. *Poems of the Late T'ang.* Rpt. Baltimore: Penguin, 1965.

Herdan, Innes, trans. *300 T'ang Poems.* Taipei: The Far East Book Co., 1973.

Legge, James, trans. *The Chinese Classics. Confucian Analects, The Great Learning, The Doctrine of the Mean,* and *The Works of Mencius.* London: Trubner & Co., 1867–76. Various rpts.

———. *The Chinese Classics*. Volume IV. *The She King*. Rpt. Taipei: Southern Materials Center, 1985.

Liu, James J.Y. *The Art of Chinese Poetry*. Chicago: University of Chicago Press, 1962.

Liu, Wu-chi, and Irving Yu-cheng Lo, eds. *Sunflower Splendor: Three Thousand Years of Chinese Poetry*. Garden City, N.Y.: Anchor Press/Doubleday, 1975.

Nienhauser, William H., Jr., ed. and comp. *The Indiana Companion to Chinese Literature*. 2nd ed. Bloomington: Indiana University Press, 1986; Taipei: SMC Publishing, 1986.

Owen, Stephen. *The End of the Chinese "Middle Ages": Essays in Mid-T'ang Literary Culture*. Stanford: Stanford University Press, 1996.

———. *The Great Age of Chinese Poetry: The High T'ang*. New Haven: Yale University Press, 1981.

Porter, Bill (Red Pine). *Road to Heaven: Encounters with Chinese Hermits*. San Francisco: Mercury House, 1993.

Red Pine and Mike O'Connor, ed. and trans. *The Clouds Should Know Me by Now: Buddhist Poet-Monks of China*. Boston: Wisdom Publications, 2000.

———. *The Collected Songs of Cold Mountain*. Port Townsend, WA: Copper Canyon Press, 2000.

Watson, Burton. *Chinese Lyricism: Shih Poetry from the Second to the Twelfth Century*. New York: Columbia University Press, 1971.

———. "Buddhist Poet-Priests of the T'ang." In *The Eastern Buddhist* 25.2 (1992): 30–58.

Yu, Pauline, trans. and commentator. *The Poetry of Wang Wei*. Bloomington: Indiana University Press, 1980.

BIOGRAPHIES OF POETS

CHANG CHI (776–c. 829), a native of Wu-chiang in Ho-chou (modern Anhwei Province and County), was a poet respected for his narrative or ballad-like verse (*yueh-fu*) depicting the harsh social conditions of the people. He passed the *chin-shih* (imperial civil service) examination in 799, and though suffering from an ailment of the eyes, served in the government in a variety of posts, including in the capital, Ch'ang-an. An accomplished poet and scholar (and recipient of a doctorate), he was a highly regarded member of Han Yu's famous Mid-T'ang literary circle, and acquainted with many contemporary poets. Some four hundred of his poems are extant, including a number of fine ones on Taoist and hermit themes.

CH'I-CHI (864–937), born in the Ch'ang-sha area of Hunan, has been ranked as one of the great Buddhist poets of the T'ang Dynasty along with Chiao-jan and Kuan-hsiu. Orphaned at an early age, he entered monastic life at a temple on Ta-kuei Mountain and, after ordination, became something of a wandering poet-monk. The style of his poems—bland and undramatic—is influenced by the poet Chia Tao. Later in life, he was given a position of authority in Lung-hsing Temple in Chingling. Of Ch'i-chi's known collections of poetry, ten have survived (containing over eight hundred poems). Burton Watson has translated a number of Ch'i-chi's poems into English (see *The Clouds Should Know Me by Now*).

CHIA TAO (779–843), born in Fang-yang near today's Beijing, was a Ch'an Buddhist monk until his early thirties. He left the Order to pursue a career of poetry encouraged by a circle of poet friends in Ch'ang-an. He held a number of minor civil service posts, but had little political ambition. His extant poems, numbering nearly four hundred, largely describe persons and places of austere reclusion. He was a master of the *lu-shih* form as developed by Tu Fu (712–70). He has had an enormous influence on Chinese Buddhist poetry.

CHIAO-JAN (730–99), born in Ch'ang-ch'eng (today's Chekiang), became an ordained monk prior to the An Lu-shan Rebellion. He was a tenth-generation descendant of the great lay Buddhist poet Hsieh Ling-yun (385–443). His best-known poems have an affinity with the tradition of the lay-Buddhist poet Wang Wei. In his mid-fifties, he went into semi-retirement, during which time he wrote two major critical works on poetics, the *Shih-shih* (Poetic Form) and the *Shih-p'ing* (Comments on Poetry). Chiao-jan has seven extant collections of poetry.

CH'IU WEI (c. eighth century), born in Chia-hsing in Su-chou, rose through official ranks to a position of service to the heir apparent in the imperial palace. He is remembered as an example of filial piety, having supported his stepmother most of her life. A close friend of the poets Wang Wei and Liu Chang-ch'ing, he has only thirteen surviving poems. He retired from government service in his eighties and died at age ninety-six.

HAN-SHAN (Cold Mountain) was a Mid-T'ang hermit-poet who lived in the T'ien-t'ai Mountains in Chekiang Province. Although his poems were under-appreciated by the Chinese literati through the years, he has always been revered by Buddhists and Buddhist poets—and in recent decades, by numerous Western writers and poets. Of his roughly three hundred extant poems, most describe his life of reclusion and his Buddhist-Taoist philosophy. Han-shan had two hermit friends, Shih-te (Pickup) and Feng-kan (Big Stick), who were also poets.

HO CHIH-CHANG (659–745), from Yung-hsing in Yueh-chou (Chekiang), was a talented, unconventional, and colorful personality with a long political career under the liberal reign of Emperor Hsuan-tsung. He befriended Li Po when that poet first came to the capital. Late in life after an illness, he resigned his office and became a Taoist monk, making his very home into a Taoist shrine. He gave himself the name Ssu-ming k'uang-k'o ("the bright and wild one"). Only one small collection of his poems survives.

HSIEH LING-CHIH (fl. early eighth century) was born in Ch'ang-hsi in today's Fukien Province. He became a tutor of Crown Prince Su-tsung. He stayed in the post for many years, finally returning to his home on foot. When Su-tsung became emperor in 756, he honored Hsieh Ling-chih by public tribute for his years of service. Only two of his poems are extant.

JEN FAN (Late T'ang) originally had one collection of poetry; only eighteen poems survive.

KUAN-HSIU (832–912), a native of Lan-ch'i in Wu-chou (modern Chekiang), was orphaned and entered monastic life at an early age. A painter, poet, and calligrapher, he became in late life a celebrated Buddhist priest and prelate in the newly founded kingdom of Shu (Szechwan). He is recognized as one of the great Buddhist poets of his age. Twenty collections of his poems survive.

LI PO (701–62), born somewhere in far west China or farther, is counted by Chinese among the three greatest Chinese poets (the others being Li Po's close friend Tu Fu, and Wang Wei). After serving at court in Ch'ang-an when younger, he found himself entangled in a dangerous political plot during the period of the An Lu-shan Rebellion and was banished for treason. His extant poems number over a thousand.

LI SHE (Mid-T'ang), from Loyang, lived with his brother in reclusion on Lu Mountain in central China. Later he served as an interpreter and secretary in the imperial palace for the crown prince. Exiled to Hsia-chou, he became a military staff officer in charge of granaries. He was also a recipient of a doctorate. His last days were spent in Kuang-chou. One collection of his poems is extant.

LIU CHANG-CH'ING (c. 710–after 787), a native of Ho-chien (in today's Hopei Province), is another poet in the Wang Wei tradition of landscape poetry and nature mysticism. Liu was epecially famous for his five-character regulated verse. In 733, he rather precociously passed the imperial civil service exam and was in office—mostly in undistinguished posts—up to the An Lu-shan Rebellion. After years of an up-and-down career—he was banished and possibly jailed more than once—he finally became governor of Sui-chou in today's northern Hupei. He has more than five hundred poems extant, of which only a few are translated into English.

LIU TZUNG-YUAN (773–819), a native of P'u-chou in Ho-tung (Shansi Province), rose swiftly in the civil government, only to be assigned a minor post away from the capital after the abdication of Emperor Shun-tsung owing to illness. According to commentators, it was during this period of exile that Liu matured as both a poet and an essayist. A nature poet, his poems have a closer affinity to the High T'ang era than to the Mid-T'ang to which he belonged. His surviving corpus is one hundred and eighty poems in five collections.

MA TAI (Mid-ninth century) was a successful candidate of the imperial civil service examination and served in official posts, including collator of texts and—after falling for a time into political disfavor—posts on the army staff. Most importantly, he was a good poet and scholar (receiving the equivalent of a doctorate). Ma Tai was a friend of the poets Chia Tao and Yao Ho. From time to time he lived in retreat, Hau Mountain being one favored refuge. Approximately one hundred of his poems survive.

MENG HAO-JAN (689–740), born in Hsiang-yang in Hupei Province, was a major poet of the High T'ang period. He failed the imperial civil service examination and did not pursue a civil service career. Although he spent time in the capital and at Loyang, and thus was able to know his poet contemporaries, including Li Po and Wang Wei, he lived most of his life as a recluse in or near his native town. His nature poems are rich with the details of local flora and fauna. More than two hundred of his poems survive.

PAO JUNG, a successful candidate of the imperial civil service examination during the reign of Emperor Hsien-tsung (806–20), was a contemporary and friend of the poets Han Yu and Meng Chiao (751–814). He has three surviving collections.

PO CHU-I (772–846), born in Hsin-chen (Honan Province), rose from poverty to become one of the most famous Chinese poets. His political career included numerous medium-to-high-ranking government positions. He was twice provincial governor at Hang-chou and once at Su-chou, positions that came to him after exile for criticism of the government. In mid-career, dissatisfied with political affairs, he turned his attention to the study of Buddhism, but still held high office until late in life. Due to the beauty and clarity of his writing, his work has reached many classes of people. His long poem "Unending Sorrow," recounting the tragedy of Yang Kuei-fei and the fall of Emperor Hsuan Tsung, is the poet's tour de force of popular literature. Po Chu-i was a prolific writer, with nearly three thousand of his poems preserved.

SHIH CHIEN-WU (fl. 820), a native of Kung-chou and a successful candidate of the imperial civil service examination during the reign of Emperor Hsien-tsung (806–20), became a recluse on West Mountain near his birthplace. His *Hsi-shan chi* ("West Mountain Collection") consisted of ten books; only one book survives.

SZU K'UNG-T'U (837–908), thought to have been born in Szu-shui in today's Anhwei Province or in Yu-hsiang in Ho-chung (Shansi Province), served in high official posts, but toward the end of the dynasty chose reclusive life on his estate in the Chung-t'iao Mountains. There he wrote landscape poems and turned to Ch'an Buddhism and Taoism. It is said that later when summoned again to court, he hesitated to resume office. When the last T'ang emperor was murdered by a usurper, it is recorded that Szu K'ung-t'u starved himself to death. In addition to a long poem on poetry called the *Erh-shih-ssu-p'in* ("Poetry's Twenty-four Moods"), he wrote mostly short nature poems in the tradition of Wang Wei. Of his ten poetry collections, only three survive.

TAI SHU-LUN (731–89), a native of Chin-t'an in Jun-chou (today's Kiangsu Province), was a successful government official as well as a poet (especially of *yueh-fu*). After the death of Emperor Tai-tsung in 779, Tai was banished from the imperial court and served the next ten years in provincial posts, including that of governor at Fu-chou. There he concerned himself with agricultural matters, specifically irrigation projects, for which he received the gratitude of the people. Toward the end of his career, he held a post in military defense in a border district. Summoned at last back to the capital, he died before reaching there. He wrote ten collections of poems, though only two are extant.

T'AI-SHANG YIN-CHE (Recluse T'ai-shang) (Mid-T'ang) was an eremite dwelling in the Chung-nan Mountains. He has no recorded surname or given name; he named himself.

TU MU (803–52), born in Chang-an, came from a good family (he was the grandson of a great statesman and scholar) whose fortune was waning. He passed the imperial civil service examination at age twenty-five and held middle-level offices off and on throughout his career, but to his frustration he never advanced to high office. He was known for his strong moral character, at one time retiring from public office to care for his younger brother who was going blind. Minimally translated (see A.C. Graham's *Late T'ang*), Tu Mu is best known to the West as a poet of seven-character lyrical quatrains. His extant work numbers just over five hundred poems.

WANG WEI (701–61), born in the district of Ch'i (modern Shansi), was a famous poet, painter, musician, and calligrapher. Successful in political life, he rose to the high position of right assistant director of the department of state affairs. Compelled to serve in the An Lu-shan administration, he was accused of sedition when the imperial court was restored. His brother saved his life, and he subsequently retired to his villa in the Chung-nan Mountains near the Wei River. While serving in the government, he studied with the Ch'an Master Tao-Kuang for ten years. He has some four hundred poems extant, the best of which are known for their quiet images of nature. Su Tung-p'o, a poet of the Sung Dynasty, is reported to have said that "in Wang Wei's poetry there is painting and in his painting there is poetry." His influence on Chinese poetry is prodigious. In his middle-to-late years, Wang Wei was a devout lay Buddhist.

YAO HO (fl. 831), a native of Hsia-shih in Shensi Province, was a poet official and grandson of a prime minister. After passing the imperial civil service examination, he assumed a series of posts, including that of chief registrar. He was ultimately transferred to Hang-chou where he became the provincial governor. Toward the end of his official career, he was recalled to the capital and to high government office. Yao Ho, an important member of Chia Tao's Mid-T'ang poetry circle in the capital, traveled with other poets of the circle, including Ma Tai and Chang Chi. He produced seven collections of poetry.

LIST OF ILLUSTRATIONS

INDEX OF POEMS

143

ABOUT WISDOM PUBLICATIONS

WISDOM PUBLICATIONS, a not-for-profit publisher, is dedicated to making available authentic Buddhist works for the benefit of all. We publish translations of the sutras and tantras, commentaries and teachings of past and contemporary Buddhist masters, and original works by the world's leading Buddhist scholars. We publish our titles with the appreciation of Buddhism as a living philosophy and with the special commitment to preserve and transmit important works from all the major Buddhist traditions.

To learn more about Wisdom, or to browse books online, visit our website at wisdompubs.org. You may request a copy of our mail-order catalog online or by writing to:

Wisdom Publications
199 Elm Street
Somerville, Massachusetts 02144 USA
Telephone: (617) 776-7416
Fax: (617) 776-7841
Email: info@wisdompubs.org
www.wisdompubs.org

THE WISDOM TRUST

As a not-for-profit publisher, Wisdom is dedicated to the publication of fine Dharma books for the benefit of all sentient beings and dependent upon the kindness and generosity of sponsors in order to do so. If you would like to make a donation to Wisdom, please do so through our Somerville office. If you would like to sponsor the publication of a book, please write or email us at the address above.

Thank you.

Wisdom is a nonprofit, charitable 501(c)(3) organization affiliated with the Foundation for the Preservation of the Mahayana Tradition (FPMT).